Shape of Space
The Sculpture of George Sugarman

*"My absolute conviction is that the purpose of a sculptor
is to create the presence of space."*
George Sugarman

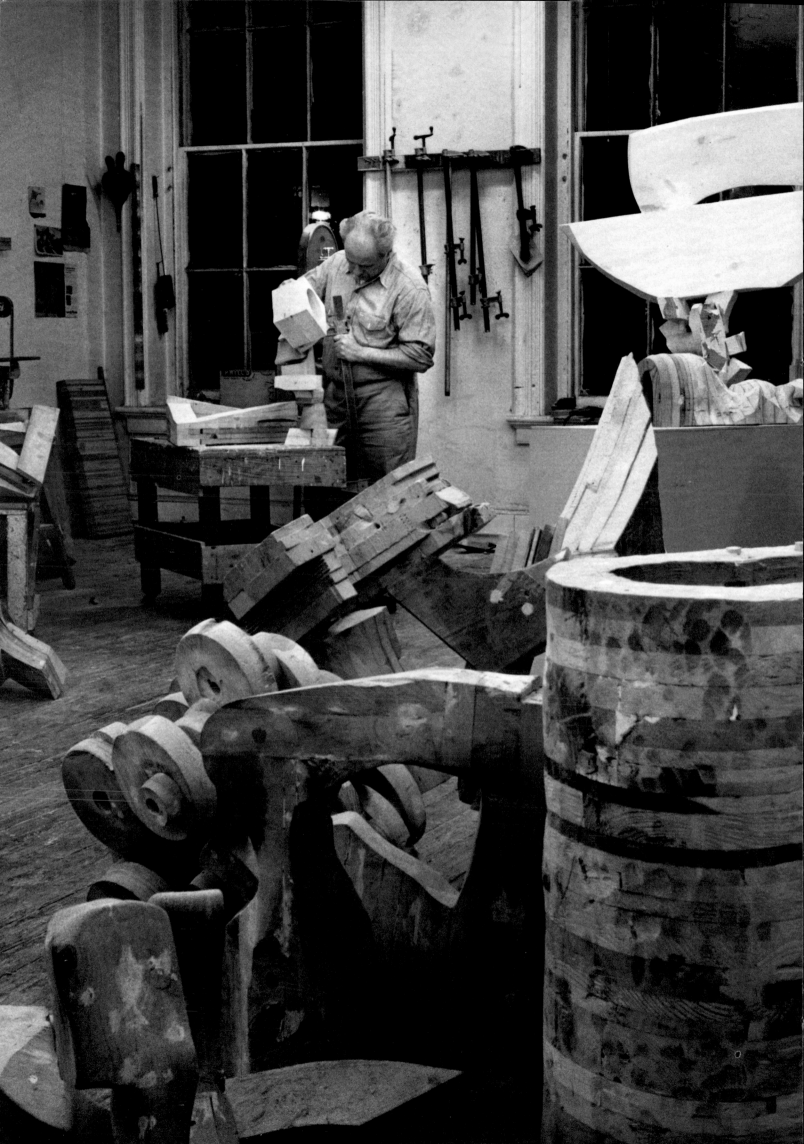

Shape of Space
The Sculpture of George Sugarman

by Holliday T. Day
with contributions by Irving Sandler
and Brad Davis

Published by Joslyn Art Museum, Omaha, Nebraska
in association with The Arts Publisher, Inc., New York

This exhibition was funded in part by the National Endowment for the Arts, a federal agency.

EXHIBITION SCHEDULE

Joslyn Art Museum, Omaha
December 6, 1981–January 31, 1982

Institute of Contemporary Art, Philadelphia
March 15–April 24, 1982

Columbus Museum of Art, Ohio
August 28–October 10, 1982

First Edition
©1981, Joslyn Art Museum

Published by
Joslyn Art Museum, Omaha, Nebraska
in association with
The Arts Publisher, Inc., New York

Cover
Two in One, 1966
Building: Joslyn Art Museum east entrance
Photo: Malcolm Varon

Frontispiece
Sugarman in his studio, ca. 1966
Photo: John A. Ferrari

Designer: Julie Toffaletti

Photography: Jon Blum — cat. no. 15; Rudolph Burckhardt — cat. no. 2, 4, 5, 7, 9; Bevan Davies — cat. no. 31; Helga Photo Studio, Inc. — cat. no. 20; eeva-inkeri — cat. no. 3, 13, 14, 24, 30, 33, 34, 35, 37, 40, 43; John A. Ferrari — cat. no. 12, 21; Fischbach Gallery — cat. no. 22, 25; Julius Kozlowski — cat. no. 6, 26, 28, 29, 36, cardboard sketches; George Miles — drawings; Photo-Graphics — cat. no. 10; Eric Pollitzer — cat. no. 11; David Stansbury — cat. no. 17, 23, 32; Adolph Studley — cat. no. 16, 18.

Composition: *Bembo* by Western Typesetting Company/Omaha

Production: The Arts Publisher, Inc. Paper stock is 100 lb. Vintage Gloss text

Library of Congress Cataloging in Publication Data

Day, Holliday T.
 Shape of Space.

 Bibliography: p.
 1. Sugarman, George, 1912– —Exhibitions.
I. Sugarman, George, 1912– II. Sandler,
Irving, 1925– . III. Davis, Brad.
IV. Joslyn Art Museum V. Title.
NB237.S9A4 1981 730'.92'4 81-18645
ISBN 0-936364-07-6 AACR2
ISBN 0-936364-06-8 (pbk.)

Contents

Foreword

The Joslyn Art Musuem begins the celebration of its fiftieth anniversary year with the first American retrospective of the sculpture of George Sugarman. Sugarman's work, in its striking bold colors and abundance of invented forms, embodies the spirit of celebration, a celebration of the spirit of independence and innovation.

Independent of the fashions in art, Sugarman has never ceased to be involved in the artistic dialogues of his time. His interests, however, have always been wide ranging, encompassing art history, architecture, theater, dance, music, philosophy, and science. All of these interests inspire and infuse his work, opening it up to complex layers of interpretation as documented in the book's essays.

Sugarman's work is understood best, not in terms of the progression of art movements he has lived through — Cubism, Abstract Expressionism, Minimalism, and most recently, Pattern and Decoration — but in counterpoint to them. The complexity and independence of his work defies easy categorization, and as such, it has often received less critical attention.

Only recently have the possibilities inherent in his diverse forms begun to be more fully appreciated. A new generation of artists and art historians look on Sugarman's thirty-year career as an island of personal artistic integrity and absolute conviction in a whirling sea of changing trends and labels.

Beyond the initial emotion evoked by the show's exuberant colors and forms, it is possible to approach the exhibition through the internal logic and structure of individual works. Each has a continuity of interests: energy, relationship to the surrounding space, unity in a complex diversity, continuity and change, openness.

Henry Flood Robert, Jr.
Director

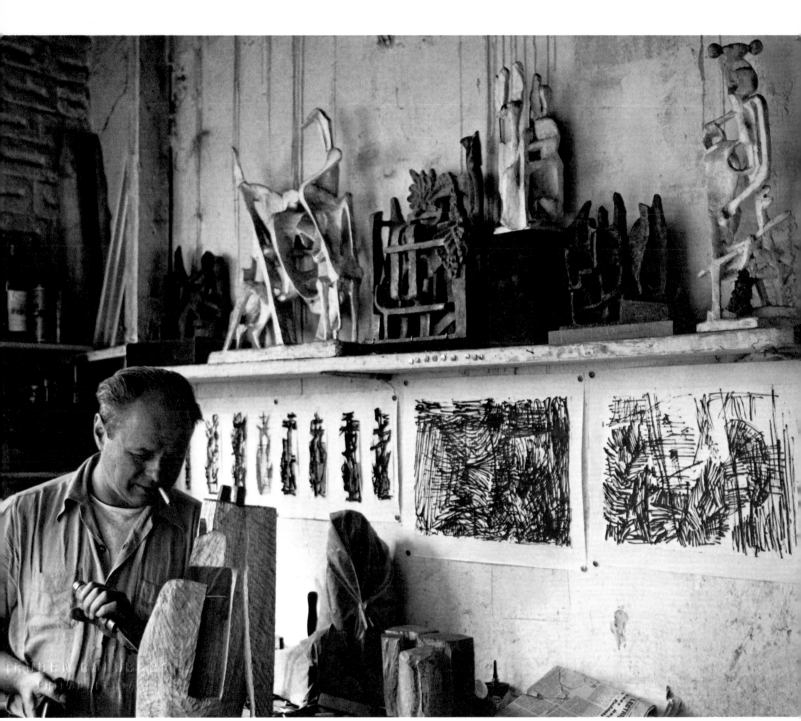

Sugarman in the studio with early terra–cotta pieces on shelf, about 1956. Photo: Reuben Goldberg

by Holliday T. Day

Shape of Space
The Sculpture of George Sugarman

George Sugarman belongs to that rare breed of artists whose work always looks contemporary without losing the continuity of its formal concerns. Interest in his sculpture is as strong today as it was twenty-three years ago when he won a Carnegie Institute award in Pittsburgh for *Six Forms in Pine*. His early sculptures, made in Paris in the early fifties, were influenced by the Cubists, although already he was moving away from their tight interlocking masses to a more open, abstract concept of form. Later when he returned to New York, he was one of the first sculptors to use raw, concentrated local color as blatantly as the Pop artists of the period. In the sixties, he led the search for new solutions to the space/form dilemma as his polychromed constructions cascaded off the pedestal and sprawled onto the floor. And in the seventies, he seriously questioned the elitist and iconic premises of public sculpture and created airy open environments empathetic to the passerby. Finally, the recent appreciation of George Sugarman's works by the "Decorative" group of artists[1] suggests how wide-ranging his appeal can be. Yet Sugarman is a maverick, not a follower of fashion in art. Moreover, his work has a consistent vision that relates his earliest sculpture to his latest.

It is the nature of Sugarman's artistic vision that leads to the anomaly of his being simultaneously both maverick and *au courant*. Developing from a multiplicity of interests, particularly in architecture and science, this vision seeks the unity which encompasses the diversity and energy of life. Hydra-like in its reaches, it remains the most enigmatic and fascinating aspect of his work.

Architecture has had both formal and philosophical lessons for Sugarman. During his European travels in the fifties, he found in the architecture of Bernini and Borromini a confirmation of the inherent dynamism of space. Baroque unification of form and space into a lively organic whole taught Sugarman how to integrate irregular intervals and voids into his works. Michelangelo's clarity of form and emotional use of space also struck Sugarman as important.[2] Later, his architectural interests included the palaces and mosques of Islam.

Perhaps the most memorable impact of architecture for him was philosophical. When Sugarman returned to New York in 1955, he was immediately struck by the "conglomerate but somehow cohesive structure of the city"[3] in contrast to the architectural unity of Haussmann's Paris. The conglomerate architecture in New York, as well as the multitudinous forms of artistic expression, possessed for Sugarman a total energy which, although unplanned, gained a force from its cumulative effect

1. The "Decorative" artists include Robert Kushner, Brad Davis, Kim MacConnel, Cynthia Carlson, and others who showed together in such exhibitions as "The Decorative Impulse" at the Institute of Contemporary Art, University of Pennsylvania, 1979, "Arabesque" at the Contemporary Arts Center, Cincinnati, 1978, and "Patterning and Decorating," Museum of the Americas Foundation for the Arts, Miami, 1977.
2. George Sugarman, letter to Holliday T. Day, 21 June 1981.
3. George Sugarman, "Summary of Career" (ca. 1962), George Sugarman Papers (GSP), Archives of American Art, Washington, D.C.

that was far greater than its parts. This idea of a unity made up of disparate objects without an overall plan became central to his work.

Sugarman's philosophical idea of unity out of disparity had formal consequences for his art. Clearly planned unity predicates a consistent uniform whole that is static, closed, and finished in time. It implies a sculptural form focused on volume existing within a unified illusionistic space signifying a unified and idealized world.[4] Unplanned unity suggests a different kind of reality. For Sugarman, life is not static but changing and open-ended. Such a philosophy allows him to adopt new ideas while still maintaining the integrity of his art. As he expresses it, he feels he should throw in everything except the kitchen sink, and maybe that too, should be included. He wants to combine conflicting ideas and shapes while still maintaining unity, such as the combination of geometric and organic forms, both linear and volumetric, in *Inscape*, his unique field sculpture of the early sixties.

Science, like architecture, provides a philosophical underpinning to many of Sugarman's sculptural ideas. For him, science clearly represents an ultimate reality which competes with and parallels that of art's reality. In one of his many notes grappling with the distinction between these differing realities, he writes,

> Science, in so far as it concerns itself with itself as a system and a total structure, admitting only that part of knowledge which fits the structure, is an art of poetic creation, brutal and wishfully all-encompassing. It is not the scientific attitude of the discovery of facts which has killed poetry. It is that the

poetry of science is more powerful, more searching, more persuasive than anything we can invent now.[5]

In his art, Sugarman reflects the attempt of physics to understand the existential disorder of life with its increasing entropy and its endless processes. Like the paradox of the wave-particle nature of light, Sugarman explores the continuous-discontinuous nature of space/form through his "field" sculptures like *Two in One*. Modern physics, like sculpture, deals with the nature of space. Although it may be unconscious, I do not think it is an accident that Sugarman calls these multipart sculptures "field" sculptures when physics' most fundamental problem is the development of a unified field theory. If physics is the study of motion, the same can be said about Sugarman's sculpture. Form described through motion accounts for his interest in dance as well as in waves or cascading falls. Likewise, the accretion of forms and formation of interior spaces through biological growth in plants and shells continue to interest him.

Sugarman's relationship to scientific thought needs to be continually reiterated: so often it is remarked how playful his work looks, how suitable it is for children because of its bright colors.[6] To place that emphasis on Sugarman's work is to lose its fundamental *raison d'etre*. For Sugarman, just as for an artist who only uses somber blacks, art is his life, his existence, his soul. Or, as the German art critic Werner Haftmann said: "the artist had to re-dream, to become invaded by disquieting and poetic visions of new space, rhythms, and movements which govern our modern world, binding time and space, matter and energy in new ways."[7]

4. Donald Judd, "In the Galleries," *Arts* 36 (September 1962):55.
5. George Sugarman, GSP (ca. 1966).
6. David Weinrib discusses this problem in Bruce Glaser et al., "Where Do We Go From Here?" *Contemporary Sculpture: Arts Yearbook 8* (New York: The Art Digest, 1965), p. 152.
7. George Sugarman, GSP, undated. Sugarman's version of "Here again, the artist has his role; he has placed himself at the interior and has allowed himself to become invaded by disquieting and poetic visions of new space, by rhythms and mobilities which govern the world, strange alchemies which bind time and space, matter and energy." Werner Haftmann, "On the Content of Contemporary Art," *Quadrum* 7 (April 1959): 182-4.

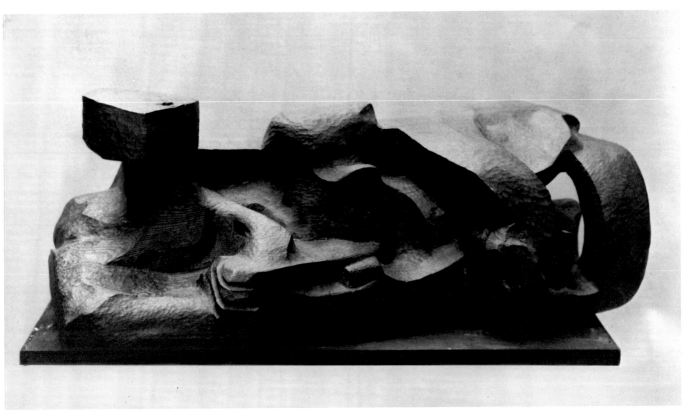

1. *Untitled Three Abstract Figures*, 1952–53

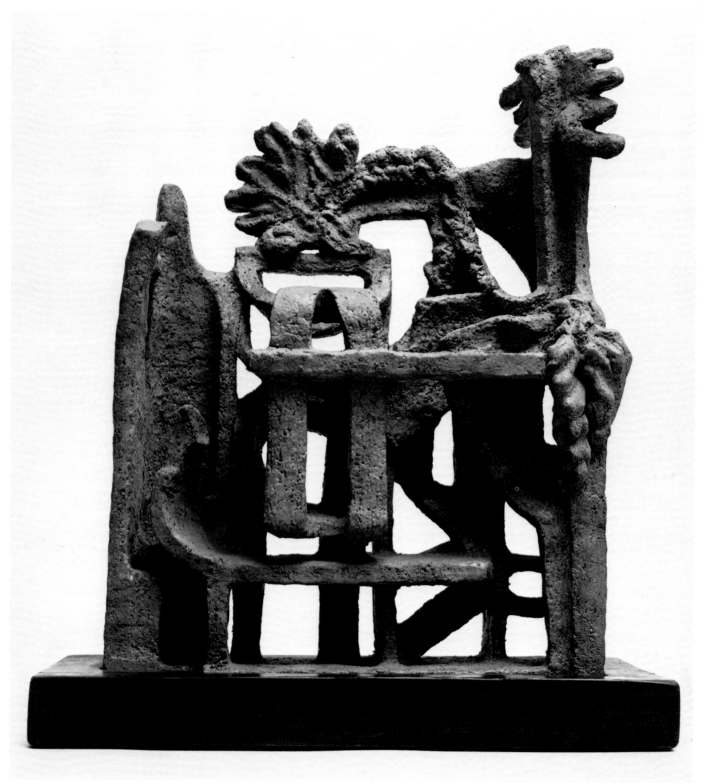

2. *Memories of Mortality*, 1953

Chapter I

Sugarman's artistic career has curious anomalies because of his late start in life as an artist and his subsequent lengthy stay in Europe. Thirty-nine when he left for Paris to begin his year-long study with Ossip Zadkine,[1] he traveled in Europe another three years before returning to New York in 1955 to begin his career as an artist. Consequently, Sugarman became a "sixties sculptor," although his age and Cubist training normally would have associated him with artists whose reputations were made in the fifties and whose ideas were formed in the thirties and forties. Ten years older than his closest friends, Sugarman worked with a compulsive urgency to make up for lost time. His maturity and experience gave him the advantage of knowing his goals. Sugarman had acquired in Europe an understanding of the structure and order of Cubism. But more important to his future development as an artist was his exposure to European art and architecture, especially the Baroque in Italy and Spain, which gave him an enlarged view of the role of art in society.

The New York that Sugarman had left was quite different from the city to which he returned in 1955. Subjects of hostile ridicule in 1950, the Abstract Expressionist painters were princes of the realm by 1955. Pollock, Motherwell, and de Kooning exhibited almost every year in museums and galleries. The *cognoscenti* bought their work, while younger artists imitated their style. Hans Namuth's famous photographs of Pollock glorified the process of painting.[2] Sculpture, however, seemed of little interest to the public. Even artists as well respected as David Smith had difficulty getting exhibitions and selling work.

The most prominent[3] sculptors, like the Abstract Expressionist painters, were influenced by Cubist form and Surrealist process. With the exception of Louise Nevelson, most of them worked primarily in metal, creating assemblages from the discarded and battered detritus of industrial society. Artists such as Richard Stankiewicz and David Smith drew on the former associations of materials for emotional impact. Bronze work had an artificially induced patina of age, and iron and steel work, if it were not already so blessed, rapidly acquired its patina of age from rust. These patinas were intended to enhance the totemic or ritualistic aspect of the artwork. Many sculptors dwelt on accident or process by crushing

1. Zadkine, a Cubist sculptor whose work is similar in concept to his teacher's, Lipchitz, seems a curious choice for a man who had never made any sculpture prior to arriving in Paris. Nevertheless, Zadkine taught many young American painters after World War II, such as Kenneth Noland and Ellsworth Kelly, as well as sculptors such as Richard Stankiewicz, Sidney Geist, and Gabriel Kohn.

2. Francis V. O'Connor and Eugene Thaw, *Jackson Pollock*, vol. 4 (New Haven: Yale University Press, 1978), pp. 250-252.

3. The Museum of Modern Art's exhibition "The Art of Assemblage" capsulized this group of sculptors in 1961. Included in the exhibition were Herbert Ferber, Ibram Lassaw, Theodore Roszak, David Smith, Richard Stankiewicz, and Louise Nevelson.

metal and by leaving solder welds on the finished sculpture.[4]

Sugarman arrived in New York with a very different aesthetic focus. The shape of space was his concern. His thinking about space derived from Picasso, Archipenko, and Zadkine's teacher, Lipchitz, and he rejected Surrealist preoccupation with association, myth, accident, and process. The Surrealists' concern for the subconscious, the primitive, and the irrational contradicted Sugarman's concept of a world that is complex and diverse, but nevertheless ultimately rational and explainable.[5] His universe expanded outward and forward, not inward and backward.

Sugarman combined a modified Cubist idea, that form is space, with a Baroque love for complexity and extension. He adopted Picasso's juxtapositions of discrete, clear forms to rebuild space as well as Archipenko's use of voids to imply form. While Sugarman rejected the figurative nature of Cubist sculpture, he, like the Cubists, believed artists should invent forms, not imitate nature.[6] Such a view proscribed found objects or accident. Sculpture should be invented and abstract, not referential. Later this artistic ideal of inventing abstract form became central to Sugarman's polemic against minimal sculpture.

Sugarman's belief in the importance of clarity in sculptural forms[7] was consonant with his interest in science. The disjuncture of form into discrete, clear volumes by early Cubist sculptors gave their work a schema which suggested a scientific analysis of the figure. Thus their rational clear forms superseded any psychological aspects. The mythic totemic figures of David Smith or the use of automatism by Ibram Lassaw were antithetical to Sugarman's idea of science and the complexity of modern culture.

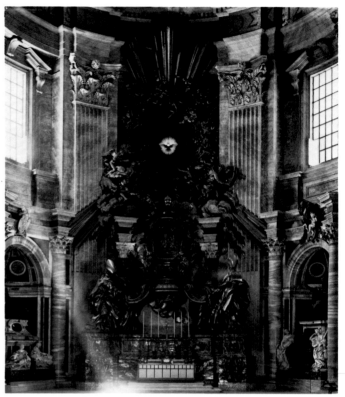

Gianlorenzo Bernini, Cathedra Petri, 1656–66, gilt bronze, marble and stucco. St. Peter's Rome. Photo: Alinari/Editorial Photocolor Archives.

A trip to Florence cemented in Sugarman's mind the importance of clarity in forms. He remembers seeing, at the end of a long hall, Michelangelo's *David* in full light and, in a seemingly dark corner, the *Slaves*. And while he stood there looking and thinking, he said to himself, "I choose the *David*," with its clear and hard forms, rather than the soft suggested forms of the *Slaves*.[8]

If Cubism taught that space creates form, Baroque art suggested the possibilities of that space/form. The Baroque was not a popular artistic source of ideas in the fifties. As Sugarman says, people used to tease him and tell him that "he was just Baroque."[9] Possibly Sugarman's lifelong interest in

4. A book such as Herbert Read's *A Concise History of Modern Sculpture* (New York: F. A. Praeger, 1964) has page after page of illustrations of corroded bronze works that look as if they were dug from some ancient grave rather than made in the fifties.

5. George Sugarman, GSP, undated.

6. The primacy of forms, as opposed to the nineteenth century idea of selection of forms from nature, was central to Lipchitz and Archipenko's sculpture even though they used those forms to make figures, as pointed out by Albert Elsen in *Origins of Modern Sculpture: Pioneers and Premises* (New York: George Braziller, 1974), p. 97.

7. Interview with George Sugarman at the artist's studio (unpublished) New York, 20 October 1980.

8. George Sugarman, letter to Holliday T. Day, 21 June 1981.

9. Ibid.

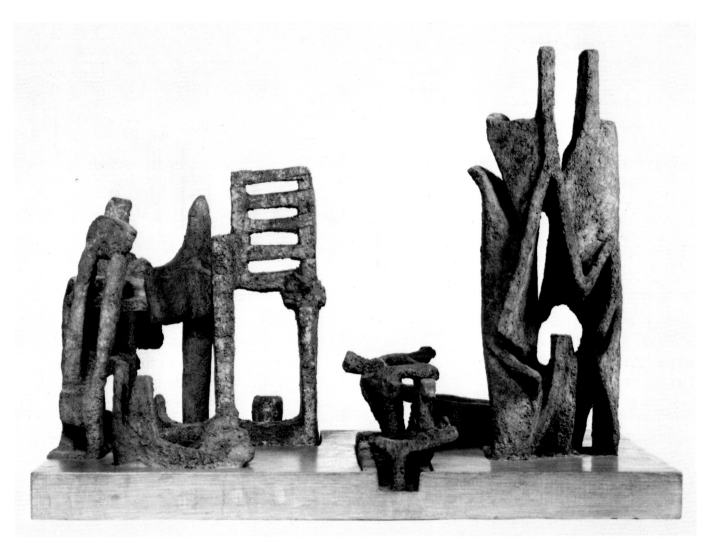

3. *Untitled Terra Cotta Group*, 1953

the theater[10] provides a natural affinity to Baroque concerns. Or perhaps Baroque art's reflection of the seventeenth century obsession with both the motion and vastness of the universe struck a sympathetic note with Sugarman's own interest in physics. At any rate, Baroque art coincided with a plethora of discoveries in physics by Galileo, Kepler, and Newton. Such a burst of significant new physical theories did not recur until the twentieth century.

The architecture and sculpture of artists like Borromini and Bernini overwhelmed Sugarman. The expansive quality of works like *The Ecstasy of St. Theresa*, which refused to be confined to its base, and the *Cathedra Petri*, which tumbled out of its niche, were completely outside of Sugarman's previous experience. The chapel became theater. The choice of dramatic moments implied a continuum through time as well as space. Sugarman began to realize the emotional quality and complexity that forms could have and still maintain their coherence. He was fascinated with the unification of San Carlo alle Quattro Fontane's complex interior into a living plastic space and with the liveliness of its facade. Yet, unlike the Baroque artists who deliberately created ambiguous spaces where one form flows amorphously into another, Sugarman kept his ideal of separate clear forms that he admired in Michelangelo's *David*.

All the ideas Sugarman brought back from Europe allied him naturally with younger artists who were rebelling against the Abstract Expressionists. Not only were his ideas clearly opposed to Surrealist beliefs in association, subjectivity, and myth, but also they were reinforced by New York's increasing preoccupation with formalism and the country's passion for science prompted by the launching of Sputnik. Sugarman became a founding member of two important groups: The New Sculpture Group[11] and Brata Gallery.[12]

Indicative of formalist concerns in New York was the debate[13] that raged in the art world about whether "academic" abstraction existed. Aggravated by the proliferation of watered-down Abstract Expressionist painting and sculpture, which flourished in the Tenth Street co-ops, the debate stemmed from a real concern that abstract art was still based on a geometrization of the conventions of figurative art of the nineteenth century. The New Sculpture Group sought a truly non-referential art utilizing new ideas of organization.

The quest to make a truly abstract sculpture was the expressed goal of many sculptors in the sixties who wished to push the concepts of sculpture beyond the early Moderns such as Picasso or Gonzales. Formal solutions to this quest were hotly debated by The New Sculpture Group. Artists sought ways to eliminate the habitual reference to the human figure made by the vertical "core" of a sculpture. In addition, they began to conceive of sculpture not as a work with finite boundaries but as a structure that extended into, penetrated, and activated the surrounding space. And finally, they pressed for a new internal logic to supplant the Cubist principle of relational composition where unity is sought by balancing and manipulating the individual parts. As will be shown, Sugarman's sculpture posed innova-

10. Sugarman's aunt took him backstage in the Hedgerow Theatre in Philadelphia when he was still a child. Interview with George Sugarman, 20 October 1980.

11. The New Sculpture Group met weekly to discuss ideas among sculptors and to arrange exhibitions. No critics were allowed, although later Irving Sandler was admitted. The group borrowed exhibition space early in the art season, which at that time went from October to April. In 1958 they showed at the cooperative gallery Hansa, and in 1959 and 1960 used the Stable Gallery in the early fall.

12. The brothers John and Nicholas Krushenick brought together twenty artists to form Brata, which means brothers. The group included Sal Romano, Edward Clark, Al Held, and Sugarman, who had all known each other in Paris, as well as Ron Bladen whom Sugarman knew through Al Held. See *Tenth Street Days: The Co-ops of the 50's* (New York: Education, Art & Service, Inc., 1977), p. 43.

13. Donald Judd, "In the Galleries: Friedel Dzubas," *Art News* 58(September 1959):17 and Irving Sandler, "Is There a New Academy?" *Art News* 58(September 1959):37. Leo Steinberg, "Contemporary Art and the Plight of the Public," *The New Art*, edited by Gregory Battcock (E. P. Dutton & Co., Inc., 1973) revised ed. Reprinted from *Harper's Magazine*, March 1962.

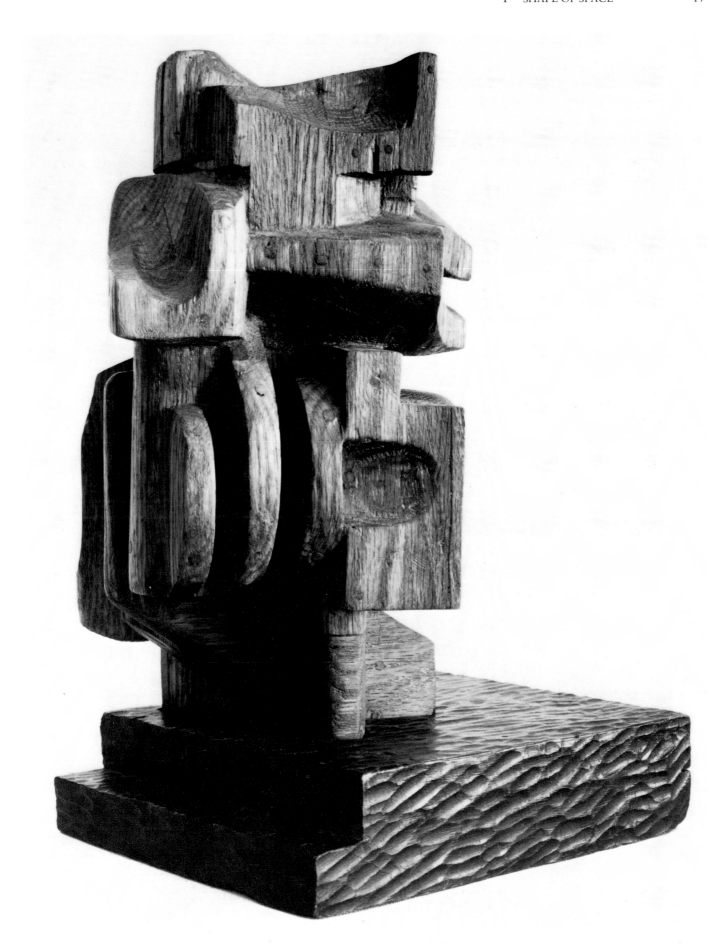

4. *Many Harbors, Many Reefs*, 1955–56

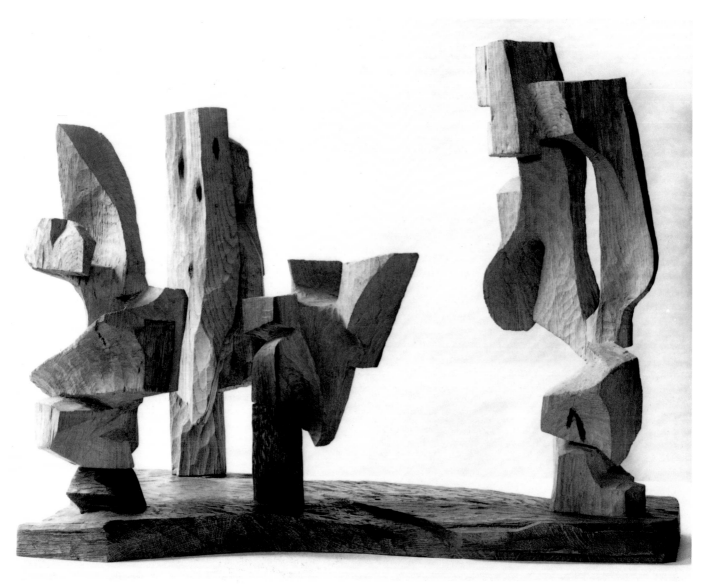

5. *Improvisation on the Winds*, 1956, oak, 22 x 27 x 14. Permanent Collection, Massachusetts Institute of Technology

tive solutions to all three of these problems, although he is rarely given credit for it.

Formalism was the religion of the sixties' art and the ability to make formal innovations was the requirement for sainthood. That Sugarman subscribed to this view was made abundantly clear in his 1969 statement:

> My main interest throughout has been in the formal aspects of art. That is to say, I believe that the meaning or content of art is expressed by the way the individual forms or the 'incidents' in a sculpture or painting relate to each other and to the whole explicit and implied space which they create. I refer to this totality as the structure and it is this structure, both visible and intuited, with all its implications for formal and even human relationships, that I consider most interesting in the visual arts.[14]

Today in 1981, when criticism focuses more on content and meaning than on form, Sugarman, whose ideas were formed earlier, continues to discuss his sculpture only in formal terms, much to the frustration of his younger admirers. Part of Sugarman's reluctance to mention the content of his work is his real fear that these ideas are usually applied too literally, confusing content with interpretation. In careless criticism, meaning often becomes too sentimental, too tied to specific association of form and color, and too linked to themes.[15] As Sugarman says, "Art has become its own reality long enough for us to give it now its own content."[16] Thus, its

structure should not depend on historical or psychological associations. Sugarman compares the experimental self-reflective nature of art to science,[17] although, unlike science, art is not verifiable.

Yet Sugarman's formal interests express his metaphysical interests. Statements such as "Art should seize on the eternal"[18] or "Art has become its own reality long enough for us to give it now its own content" make clear the importance of content. But the content of Sugarman's art does not depend on historical or psychological association, but rather on fundamental metaphysical problems such as "What is unity?" Sugarman's comparison of the experimental self-reflective nature of art to science suggests that art, like science, opens the avenues to the fundamental nature of the universe. Therefore these "formal" problems, which occur repeatedly in Sugarman's work, become grand metaphysical themes continually under exploration.

With this understanding of Sugarman's idea of content, we can comprehend the importance of his relative maturity as a beginning artist to the development of his artistic vocabulary. For at fifty a person has worked out his metaphysical beliefs in a much more comprehensive way than at thirty. Certain priorities have been established that are not possible at an earlier age. Sugarman's convictions come through in his work.

14. George Sugarman, manuscript for "Sugarman—'Square Spiral'," GSP, 1969, printed in *Art Now: New York* 1(January 1969), unpaginated.
15. Barbara Rose and Irving Sandler, "Sensibilities of the Sixties," *Art in America* 55(January/February 1967):44. Statement by Sugarman.
16. George Sugarman, GSP, manuscript for statement in the above footnote (15).
17. George Sugarman, GSP, undated.
18. Ibid. See chapter iii, p. 34.

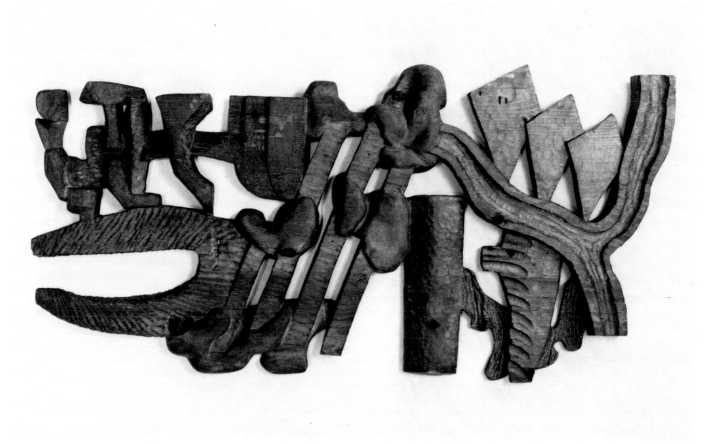

6. *West of the Mississippi*, 1956–57

Chapter II

Because of his late start, one might have expected Sugarman to be conservative in his choice of medium and methods of working. He scarcely had the time before him to develop the kind of technical polish that most artists acquire in their twenties and early thirties. In retrospect, however, he emerges as an artist devoted more to the expression of ideas than to the perfection of technical skill. In his concern with the horizontal extension of sculpture into space, he chose to disregard the traditionally imposed limits and character of his chosen medium — wood.

Before Sugarman settled on wood as his preferred medium, while still a student in Paris, he made a number of small works in traditional terra-cotta that clearly indicated Cubist influence. The interaction between the forms and their surrounding space dominates these first three-dimensional works. In *Memories of Mortality* (1953), for example, the figures do not imitate nature as much as they are articulated in a language of clear separate forms like bones of the body. Space becomes an active element penetrating and surrounding each figure. *Untitled* (1953) explores an even more inventive use of the surrounding space, where forms not only are separated from each other but also penetrate the base.[1]

Working in clay gave free rein to Sugarman's inventive powers, but it did not suit his need for size and expansion. He also rejected steel (so much favored by other sculptors of the period) because of its lack of inherent volume. Ultimately on his return to New York, Sugarman chose wood for its unique combination of strength and volume. Already in Paris he had carved a few wood pieces such as *Three Abstract Figures* (1952-53), but these were still very tentative in their exploitation of the possibilities of the material compared to his later work.

It is important to emphasize that wood for Sugarman was "only a material." He attached no mystique to its natural properties other than its adaptability to the realization of his concepts. As he said to Wendell Castle, "The natural capacity of wood is to be a tree . . . It is just another substance for making sculpture."[2]

However, in spite of his pragmatic approach, Sugarman's early work in wood was sometimes falsely linked to two earlier, but still prevalent, sculptural theories: "truth to materials," a dictum associated with Henry Moore and Brancusi, and "direct carving," which was popular in the thirties.[3] Since the premises of Sugarman's art were growth and change, supposed associations with philosophies predicated on some mythic quality of wood or on a pre-conceived static whole were an annoying misunderstanding.

Such misunderstandings should not have lasted long, for Sugarman quickly developed methods of working which were the very antithesis of the

1. Although this idea portends Sugarman's dissociated field sculptures of the sixties, it does not dominate his thinking in the fifties.
2. Wendell Castle, "Wood: George Sugarman," *Craft Horizons* 27 (March–April 1967):31.
3. These two theories stressed the natural integrity of the wood and its attendant beauty and the "release" of the image from the wood block through carving directly into it without drawings or models.

"truth to materials" dictum. He experimented by gluing and doweling chunks of wood onto the central core. In *Percussion*, for example, he brings the piece to the point of unbalance by his eccentric additions. The success of this technique led Sugarman to discover that he could build pieces entirely from laminated boards,[4] a practice which gave him more freedom to invent and also had the advantage of being economical.[5] The pallets left every day by delivery-truck drivers in the streets of New York promised an endless supply of free wood.[6] The use of laminations removed any pre-condition of size or direction and fostered the idea of an endless sculpture.

No doubt Sugarman's lengthy stay in Europe made his native land seem more poignant, for he gave these early works such titles as *Memorial to Walt Whitman* (1957), *Cornucopia* (1956), and *Improvisation on the Winds* (1956). One sculpture, *West of the Mississippi* (1956-57), even contains recognizable elements of clouds, river, rain, and arrowheads.

These roughly carved, small wooden sculptures convey a sense of romantic Americana that the beat writers like Jack Kerouac and Allen Ginsberg captured in writings on their travels across the country in the fifties as modern hobos, or that Jackson Pollock conveyed earlier in his vivid letters to his brother Charles.

> Seeing swell country and interesting people . . . experienced the most marvelous lightning storm (in Indiana). I was ready to die any moment.
>
> Dear Charles and Frank, My trip was a peach . . . The country started getting interesting in Kansas — the wheat was just beginning to turn and the farmers were making preparation for harvest. The miners and prostitutes in Terre Haute, Indiana, gave swell color — Their (sic) both starving — working for a quarter — digging their graves.[7]

Like rambling beat prose, Sugarman's early works were awkward and free-wheeling. A "good" art teacher would have trimmed and shaped them into more elegant statements. Fortunately, such a teacher never had such a chance, for today Sugarman's admirers find this excessive, slightly awkward quality of his work appealing and witty.[8]

In 1958 Shirley Kaplan, whom Sugarman had known in Paris, put together a textile exhibition entitled "New York is *the* Textile Town" in the basement at the Sixth Avenue branch of the Union Dime Savings Bank. As part of the exhibition, she wanted to incorporate some sculpture; so she arranged for a small exhibition of Sugarman's work which included *Three Abstract Figures* and *Improvisation on the Winds*. This strange beginning was Sugarman's first one-person exhibition. Lawrence Campbell from *Art News*, who reviewed the show, stated prophetically, "It looks as though he (Sugarman) knew a lot about sculpture and had a lot to say."[9]

Many of these wooden sculptures Sugarman made in the fifties were wall reliefs. The reliefs are important not only because they are forerunners of the reliefs of the seventies and eighties, but also because they explore the beginning of Sugarman's concern for the continuum. Along with other members of the Sculpture Group, he was looking for alternatives to Cubist relational composition in which emphasis is given to achieving unity by a balancing of the individual parts. Just as in architectural friezes, elements in a relief can be added endlessly in a nonrepeating series. Sugarman investigated this idea in such works as *Cornucopia* and even in *West of the Mississippi*. The latter gives the feeling of infinite extension to the left in a play on the westward expansion of the United States.

4. *Many Harbors, Many Reefs* (1955) is an early example of laminated work.
5. Sugarman's economic situation in the fifties was extremely precarious. He had no steady job, and he recalls his gratitude when Sam Francis gave him an old radio and when patrons such as Jane Suydam and the CIBA-GEIGY Corporation bought his work so that he could purchase a better grade of wood rather than pine pallets.
6. Interview with George Sugarman at the artist's studio (unpublished), New York, 16 July 1980.
7. O'Connor and Thaw, *Jackson Pollock: A Catalogue Raisonne of Paintings, Drawings, and Other Works*, vol. 4, p. 21.
8. See Recollections by Brad Davis in this catalogue.
9. Lawrence Campbell, "Reviews and Previews: New Names This Month," *Art News* 57(February 1959):17.

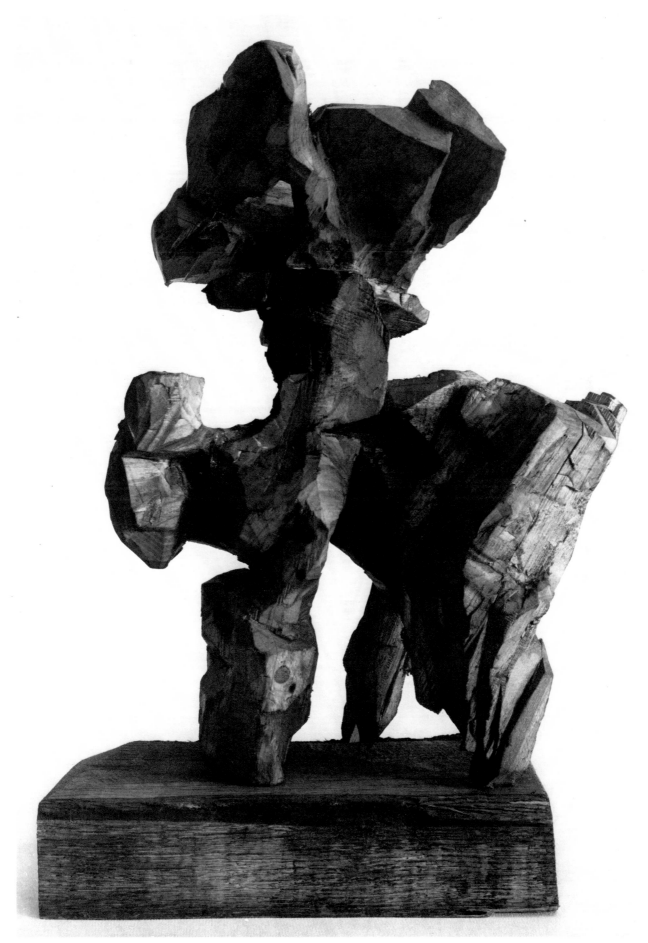

7. *Memorial to Walt Whitman*, 1957

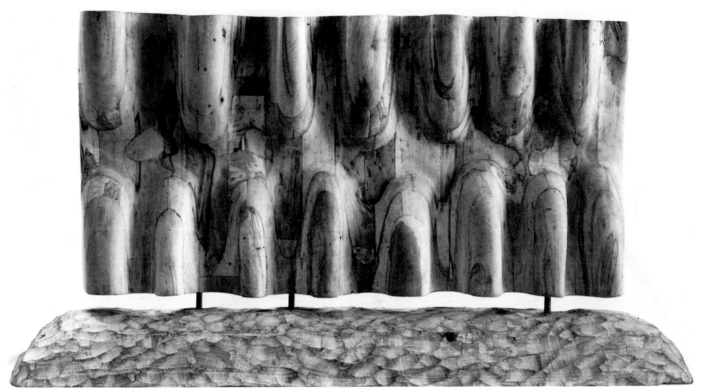

The Wave, 1958, laminated gumwood, 15 x 30 x 4 without base. Collection of the artist. Photo: Rudolph Burckhardt.

Two free-standing works made in 1959 carry this serial idea even further: *The Wall* and *The Wave*. *The Wave* is a series of regular, rounded protrusions alternating top and bottom along an upright board, while *The Wall* resembles a retaining wall or board fence with an occasional supporting post. *The Wall* in particular has no definite end or stopping point since it has no base to suggest a limit to its length.

In light of Donald Judd's subsequent interest in serial sculpture in the sixties, it is not surprising that in a review of an exhibition at Widdifield Gallery Judd noted *The Wave* above all else:

> "Mixed Mediums" is dominated by the wood sculpture of George Sugarman. One is a small undulant wall of laminated pieces of maple carved into protrusions alternating above and below and front and back. As the spacing is irregular and the multiple lines organic, the effect is not mechanical.[10]

In 1959 Sugarman made two significant sculptures that encapsulated his ideas of continuum and extension into space: *Six Forms in Pine* and the similar though later *Four Forms in Walnut*.[11] Both used a series of clear abstract forms juxtaposed in a chain. *Six Forms in Pine* is notable not only for its horizontal extension and size (nearly twelve feet long), but also for its unusual relationship to the pedestal. Suspended between two pedestals like a board between two sawhorses, the sculpture loses its vertical figure core. Laid end to end, the forms are strung out rather than contained in a closed composition. His lamination technique was superbly adapted to the demands of a composition based on the idea of accretion and a continuum. The build-up of laminations echoed the accretion of forms extended in space; the working method reiterated the visual effect. At the same time, Sugarman maintained the clarity of his separate forms. The originality of this concept won him a second prize for sculpture in the Pittsburgh "International Exhibition of Contemporary Painting and Sculpture" in 1961 at the Carnegie Institute. It was an astonishing coup. Both Alberto Giacometti and David Smith, who won first and third prizes respectively, were well-known sculptors compared to Sugarman, who had had his first one-person exhibition in a commercial gallery only the previous year.

10. Donald Judd, "Mixed Mediums," *Art News* 58(November 1959):60.
11. The abstract titles suggest the new sensitivity to abstraction vs. the referential titles of earlier works.

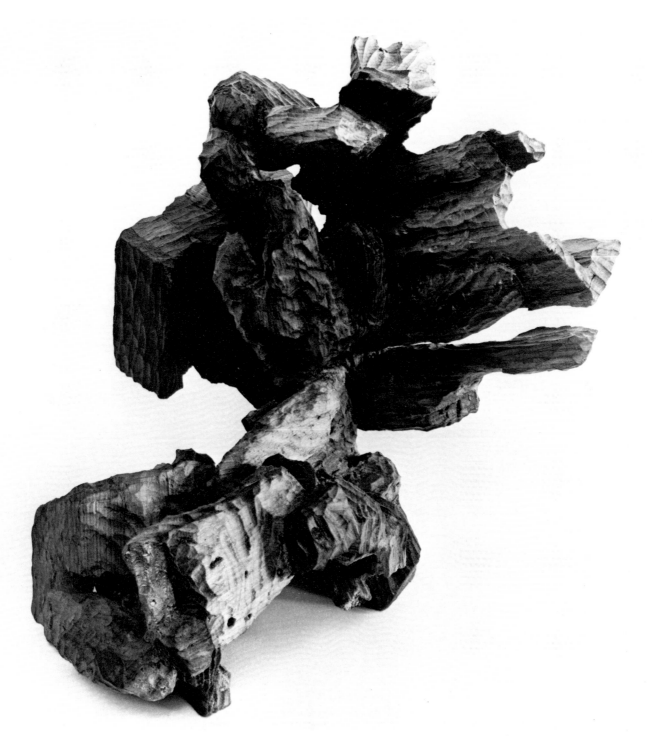

8. *Percussion*, 1957, laminated poplar, 19 x 21 x 22. The George Peabody Collection of Vanderbilt University, Gift of the Artist.

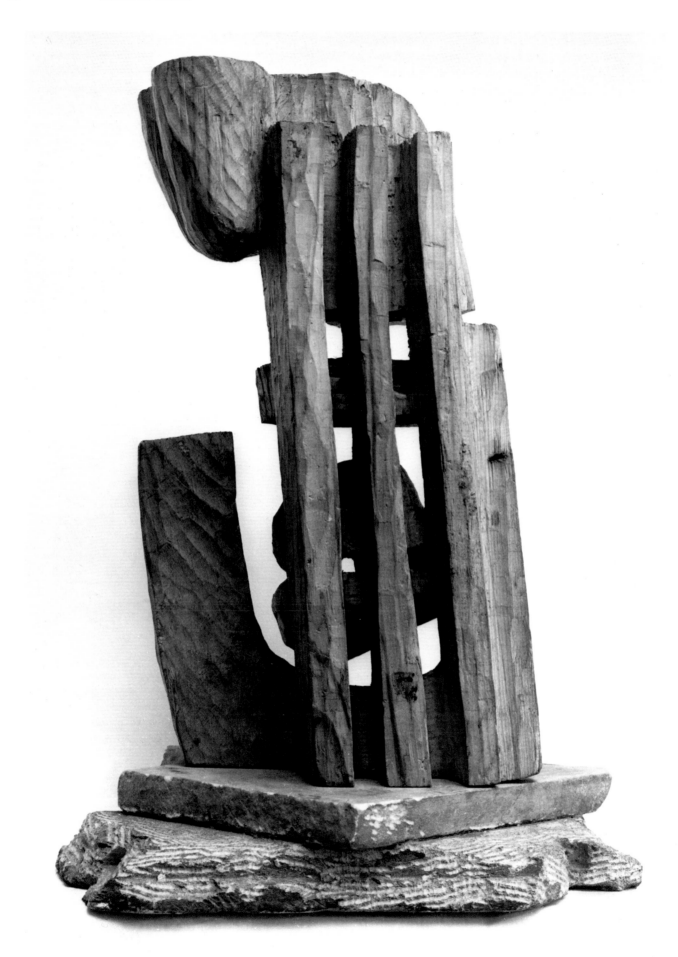

9. *The Sunken Vessel*, 1957

Despite the prize, Sugarman said nobody rushed to buy his work[12] or to give him exhibitions. Rather it created hard feelings and jealousy among other artists.[13] Although *Six Forms in Pine* went largely unnoticed by the New York dealers and collectors, it culminated a decade of experimentation in which Sugarman defined his aims as a sculptor and developed the mastery of material necessary for the first expression of those goals.

How different were the paths that Sugarman and Judd took in their exploration of the continuum as an escape from Cubist composition. Judd was to look to the precision of mathematical series in order to express infinity. Using the resources of technology rather than the human hand, he isolated single physical systems that have the potential of moving forward continuously into time and space.

Sugarman, on the contrary, looked to the complexity of the natural world with its accretions and mutations as an expression of the expanding universe. To Sugarman as to Judd, the ideal, limited, static Newtonian model of an enclosed physical system no longer seemed adequate in either physics or art; but unlike Judd, Sugarman held a more encompassing view of the universe that mathematical systems did not fully satisfy. Sugarman, an inveterate quote collector, noted:

> There is a tendency to overlook the fact that scientific work does not lead to a catalogue-like description of reality, but to models of reality. The measurable quantities are [only] the points of intersection of a net, the pattern of which is, for the most part, only conjectured and, to a lesser extent, freely invented . . .
>
> —Wolfgang Wieser,
> Biologist[14]

12. Although Sugarman was not selling work to support himself by the sixties, his financial situation was eased by a teaching position at Hunter College.

13. Interview with George Sugarman in the artist's studio (unpublished), New York, 20 October 1980.

14. GSP quoted by George Sugarman from Robert Jungk, *The Big Machine* (New York: Scribner, 1968), p. 178, translated from the German by Grace Marmor Spruch and Traude Wess, *Die Grosse Maschine* (Germany: Scherz Verlag, 1966).

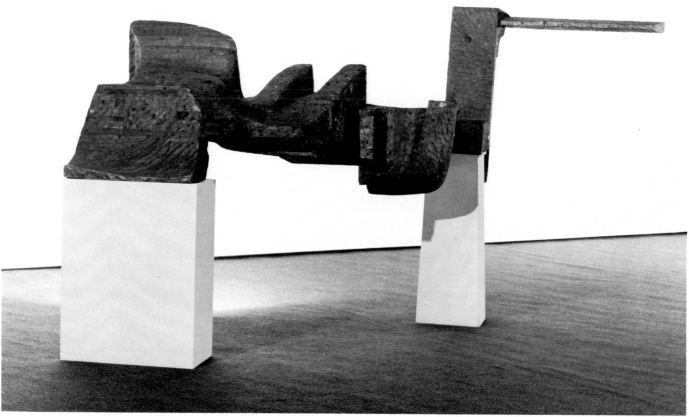

10. *Six Forms in Pine*, 1959

Chapter III

In 1959[1] Sugarman made his first polychromed work, *Yellow Top*,[2] in bright, hard, concentrated color. Unlike his later pieces, it was not conceived in color. In its unpainted state, this complex work with its layers of leaf-life forms, must have been quite confusing to the eye.[3] Dissatisfied, Sugarman felt the need to separate and clarify each of the solid areas with a different color.[4] Separating the forms through color proved to be a hard task, for he applied twelve successive coats of paint before he arrived at the present color scheme.[5] As Sugarman was to say four years later, "It's not a matter of indifference to me whether a certain form is green or black or red. Certain forms and their particular relationships to the next form must be one certain color. Whereas in the decorative sense, anything that's pleasing will do."[6]

Few sculptors were working with color in such a bold manner when Sugarman painted *Yellow Top* with bright opaque hues. In the early twentieth century, Constructivists, and later Alexander Calder, painted their planes red, white, black, and sometimes yellow. Occasionally David Smith polychromed his early sculpture, such as *Helmholtzian Landscape*.[7] In the forties and fifties the principal sculptural material was metal — bronze or steel. Artists of this period gave bronze a variety of traditional patinas ranging from green to black and sometimes painted steel a solid color, often black, which was close to the color of the bronze patinas. Unlike his earlier work most of Smith's sculptures in the fifties were bronze, steel, or silver, especially those works shown in 1960 at French & Co. Moreover, even in his painted works, such as *Five Units Equal* (1956), the paint, thinned and translucent, was intended primarily to reflect light and to manipulate the surface rather than to obscure the metal or separate the forms as it had done earlier. The paint (like the marks of the grinder in the later *Cubi* series) simulated the individual hand of the artist.

The other major artist using polychrome at that

1. Sugarman finished *Yellow Top* on December 31, 1959 — a propitious beginning to the new decade.
2. *Yellow Top* was remarkable not only for its color, but also because it stood directly on the floor without a pedestal, as did two earlier vertical natural wood works, *Untitled Column* and *The Cornerstone*, both done in 1958.
3. In addition to the complex forms, Jane Allen suggested to me that the slight tonal differences of the laminations probably worked against the forms rather than echoing them, as they had in the horizontal accordion-like shapes of *Six Forms*.
4. Interview with George Sugarman at the artist's studio (unpublished) New York, 20 October 1980.
5. Ibid.
6. Bruce Glaser et al., "Where Do We Go From Here?" *Contemporary Sculpture: Arts Yearbook 8*, p. 152.
7. The famous early polychromed work of Smith's *Helmholtzian Landscape* (1946, exhibited in 1947), which uses color, as Sugarman does, to separate forms, was not a mode continued by Smith until the 1960s, and was not exhibited again until 1969.

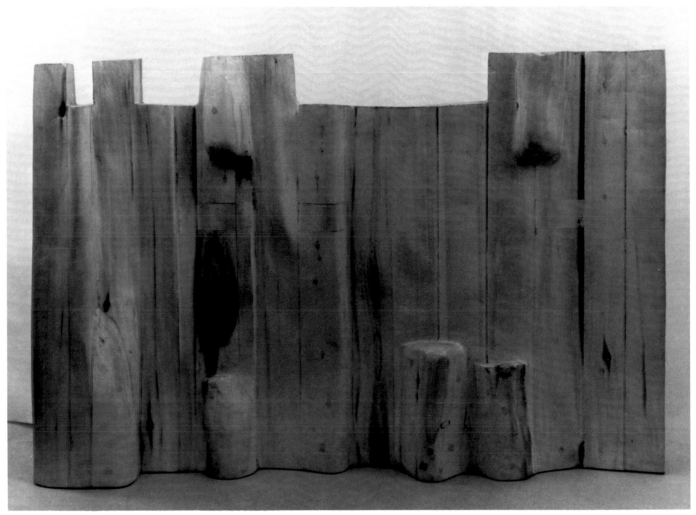

11. *The Wall*, 1959

time was John Chamberlain. His first crushed sculpture, *Shortstop* (1957), employed the already present, faded color of discarded automobile bodies. Chamberlain exhibited with The New Sculpture Group and no doubt contributed to Sugarman's background knowledge of polychromed sculpture, even though Chamberlain did not add fresh paint to his own work until much later.

However, for Sugarman, the primary inspiration for polychroming sculpture came from painting, not from these twentieth century examples of painted sculpture. Along with Al Held, a painter with whom Sugarman was closely associated during the crucial years of the later fifties and early sixties,[8] Sugarman became fascinated with the theories of color articulated by the American painter Stuart Davis, who was enjoying something of a revival during that period.[9] In the early forties, Davis had shared many concerns with the Abstract Expressionists, but by 1950 he had become critical particularly of the emotional content of Abstract Expressionism, which he called "a belch from the unconscious."[10] His reaction against the dominant style appealed to many younger artists. As Donald Judd stated in his review of Davis' 1962 exhibition in the Downtown Gallery, "There should be applause . . . Instead of compromising (with Abstract Expressionism), he kept all that he learned and invented and . . . benefited."[11]

Davis' ideas about color, space, and form are clearly revealed in the catalogue produced for the Stuart Davis retrospective in 1957. In it he sets forth the view that color has texture and size and that above all it is a spatial phenomenon.

> Color must be thought of as texture which automatically allows one to visualize it in terms of space.[12]

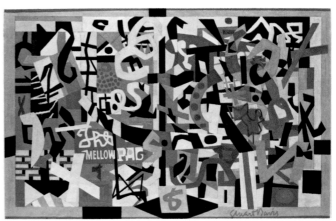

Stuart Davis, *The Mellow Pad*, 1945–51, oil on canvas, 26 x 42. Collection of Mr. and Mrs. Milton Lowenthal. Photo courtesy The Brooklyn Museum, New York.

As far as the term 'colorspace' goes, it is simply a phrase I invented for myself in the observation and thought that every time you use a color you create a space relationship. It is impossible to put two colors together, even at random, without setting up a number of other events. Both colors have a relative size.[13]

These ideas impressed Held and Sugarman, both of whom sought to use color to impart specificity and physicality to dissociative forms.[14]

The polychroming of *Yellow Top* not only served to specify Sugarman's forms, it also sharpened his perceptions about the nature of those forms, and he began to see them as falling into "families." He recalls, ". . . it was just after I finished *Yellow Top* that I realized I wasn't really changing the forms, that there were families of forms, that I would have to make my sculpture out of forms each one from a different family."[15] Thus *Yellow Top* is created from only one type, a leaf-life organic form, while the more open *Blue, Black and White* is comprised of two form families, an organic and a linear one, which are differentiated by dark and light paint as well as by

8. See discussion of their relationship in Sandler essay.

9. Diane Kelder lists twenty-one articles written between 1959 and 1963 about Davis in *Stuart Davis: A Documentary Monograph* (New York: Praeger Publishers, 1971).

10. Stuart Davis, "What Abstract Art Means to Me," *Museum of Modern Art Bulletin* 64(Spring, 1951):15.

11. Donald Judd, "In the Galleries: Stuart Davis," *Arts* 36(September 1962):44.

12. Minneapolis, Minnesota: Walker Art Center, *Stuart Davis*, by H. H. Arnason, 1957, p. 22. Exhibition traveled to the Whitney Museum of American Art.

13. Ibid., p. 44.

14. Irving Sandler, *Concrete Expressionism* (New York: New York University Press, 1965), n.p.

15. Sidney Simon, "George Sugarman," *Art International* 11(May 1967):22.

their differing shape. Sugarman sought a very specific differentiation by color of these families of forms.

> Certain forms and their particular relationship to the next form must be one certain color and even one certain shade of a certain color.[16]

Throughout the next two years Sugarman expanded this form family concept in progressively more complex works. *Three Forms in Polychrome* (1961) employed the horizontal extension of *Six Forms in Pine*, but clearly disassociated the different shapes that are organized along the horizontal rod.[17] In *Four Walls, Five Forms* (1961–62) similar forms are clustered together in masses with each mass a different color. At times these clusters are stacked in layers like books on a shelf, as in *The Second Blue and Red* (1962) or *Red, Black, Blue* (1962). Experimenting with the complexity and power of color, Sugarman tried painting each individual form of *Axum* (1963) with multicolored geometric designs. This painterly departure with its hot combos of color differed from Sugarman's normal use of a single color per form and served as a homage to Davis' *Mellow Pad*. Although this was a brilliant display of his prowess in polychrome, Sugarman henceforth returned to his idea of single-color forms, for he saw these forms in his mind as colorshapes rather than forms to be painted later.[18]

> In my sculpture, the color is as important as form and space . . . It is used to articulate the sculpture as much as form articulates the sculpture in space . . . Just as the form clarifies the space, the color works with the form to help all these other factors along.[19]

As color differentiated the forms clearly, the forms became more disparate and pushed further and further away from the compositional and gravitational center in an effort to actively take over more space. A work like *Black X* (1963) has long, convoluted, ribbon-like forms, which double back on themselves, juxtaposed to chunky masses. Others, like *One for Ornette Coleman* (1961)[20] or *Rorik* (1965), have eccentric extensions.

Two works, *Bardana* (1962–63) and *Ritual Place* (1965)[21] develop Sugarman's ideas of extension and disparate unity to their most energetic extremes. In both works, the inspiration is the Baroque. As in *Four Walls, Five Forms*, he juxtaposes a number of families of forms, but the work, instead of being static and contained, extends beyond the pedestal. The Baroque motif of the cascade, whether of water, clouds or staircases, is echoed in both *Bardana* and *Ritual Place*.[22] Like the clouds spilling out over the pediments in Bernini's *Cathedra Petri* and his *Ecstasy of St. Theresa*, the organic convolutions of Sugarman's two works fall below the pedestal toward the floor in a complex cascade. The vigorous diagonal of *Bardana*, from its darker lower section to its cloud of white C-forms, recalls the energy of the classic Baroque chariot rushing through the clouds toward heaven.

In early 1964, in preparation for an exhibition at The Jewish Museum, Sugarman began work on a new sculpture. He worked continually, in an exhausting effort without assistants, on what was to be his most extraordinary work to date, *Inscape*. Spreading out over a hundred square foot field,

16. Bruce Glaser et al., "Where Do We Go From Here?" *Contemporary Sculpture: Arts Yearbook 8*, p. 152.

17. This method became a *modus operandi* for Anthony Caro in works such as *Early One Morning* (1962).

18. Interview with George Sugarman at the artist's studio (unpublished), New York, 13 February 1981.

19. Glaser, "Where Do We Go From Here?" *Contemporary Sculpture: Arts Yearbook 8*, p. 152.

20. Sugarman's work *One for Ornette Coleman* (1961) is an appropriate dedication to that idiosyncratic avant-garde jazz musician. Both Coleman's music and Sugarman's sculpture are relatively free of conventional form and concern with shape. The *Shape of Jazz to Come*, an early Coleman album, has an ebullient, expansive structure that, despite its disparate parts, endless permutations, and chaotic feel, has an undeniable inner structure and logic. The same concept is explored in each musical key.

21. Both sculptures, major works, are in European collections.

22. The title chosen for *Ritual Place* recalls the mood of many places where cascading forms are found — not only *Cathedra Petri*, but also Michelangelo's Laurentian Library staircase and many natural settings found in parks.

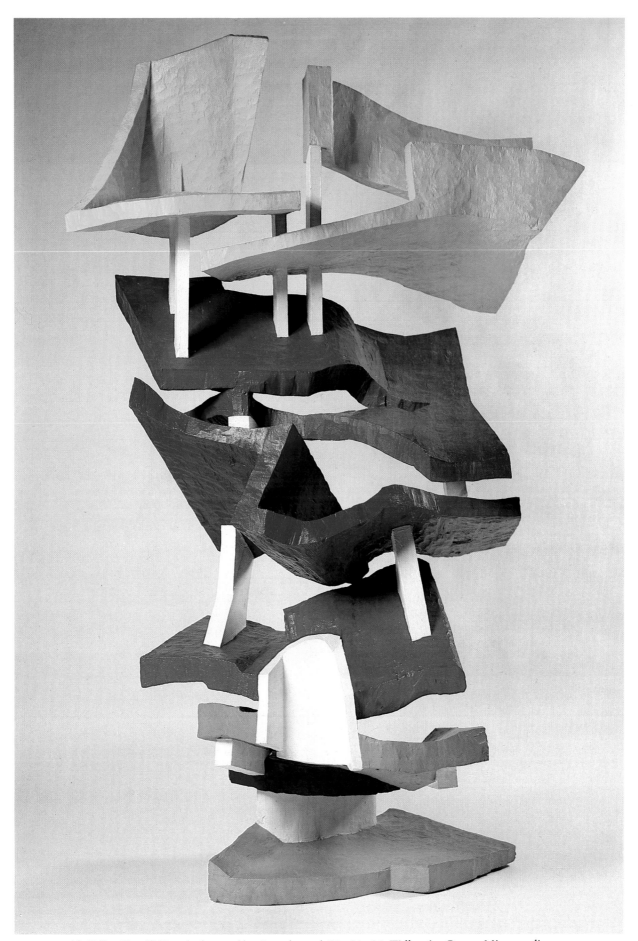

12. *Yellow Top*, 1960, polychromed laminated wood, 87 x 54 x 34. Walker Art Center, Minneapolis,
Gift of the T. B. Walker Foundation

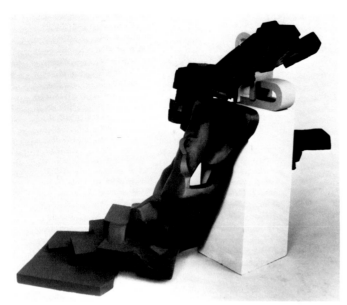

Ritual Place, 1964–65, polychromed wood, 31 x 69 x 43. Private collection, Switzerland.

Inscape meandered along the floor, barely exceeding two feet in height. In this work Sugarman could give the disparate, dissociated families of forms and the continuum their full range to activate space without worrying about the limitations gravity imposed on the large vertical superstructures of his other works. Smooth white caterpillar forms are juxtaposed to rough-hewn, flat, grass-green shapes that lead to yellow linear passages as the eye travels through this "landscape of the mind." The work appears to go on forever.

Works such as this meandering floor sculpture influenced Yvonne Rainer's early ideas about choreography. Rainer describes *Trio A*, part of the dance *The Mind is a Muscle*, as comprised of changes played against one or more constants: details executed in a context of a continuum of energy, interactive and mutually dependent movements done in a singular floor pattern, and more obvious juxtapositions that involve actual separations in space and time.[23]

In addition to being a *tour de force* of imaginative forms, *Inscape* sums up Sugarman's ideas of continuum and achieves the "existential fullness" that he seeks in his work: a path, an order through the disorder of life. Sugarman's exploration of the structure of the endless artwork coincides with a general interest in that theme by many artists of the sixties, such as Carl Andre and Donald Judd. Sugarman, like Andre and Judd, conceived of the continuum as a way of creating non-relational compositions in sculpture that would free them from Cubism. However, Sugarman chose to relate to the idea of endless expansion in a biological or metaphysical way, rather than using the predetermined, mathematical methods of Judd and Andre's Minimalism. Whereas the progressions of Judd and Andre appear to create themselves, Sugarman's permutations are clearly created by the artist, who makes infinite diversity into a unity. Lucy Lippard, writing from a Minimalist point of view, thought that although Sugarman ". . . stretched the relational concept to a new point, (he) is not working non-relationally."[24]

Sugarman, however, in seeking existential fullness, felt Minimalism to be a narrow vision which closed up the possibilities of art and denied the complexity of the physical and emotional world.[25] Art should be an investigation of the nature of expansion. Rather, he asks himself, "If matter, life, society are always in process, how do we convey that in our work?"[26] and finds the answer in another question, "But doesn't art — or should it not — seize on the eternal? Not sure, but if so, perhaps laws of relationship, of change are eternal."[27] Consequently, by 1964 he could publish the statement:

> My own work is made up of these varying relationships, as one form is placed adjacent to another, sometimes absurdly, sometimes more logically. But each piece structures the space it moves through and implies the space it might continue to move through,

23. Program notes for the performance of *The Mind is a Muscle* at Anderson Theatre, New York, on April 11, 14, and 15, 1968.

24. Lucy Lippard, "New York Letter," *Art International* 9(June 1965):57.

25. It should be noted that Sugarman's objections to Minimalism were not the same as Clement Greenberg's and Michael Fried's, who objected to the theatrical element and the use of color which, in their eyes, subverted the physical quality of sculpture. See Clement Greenberg, *Art and Culture* (Boston: Beacon Press, 1961), p. 206, and Michael Fried, "Art and Objecthood," *Art Forum* 5(Summer 1967):15.

26. George Sugarman, GSP, undated.

27. Ibid.

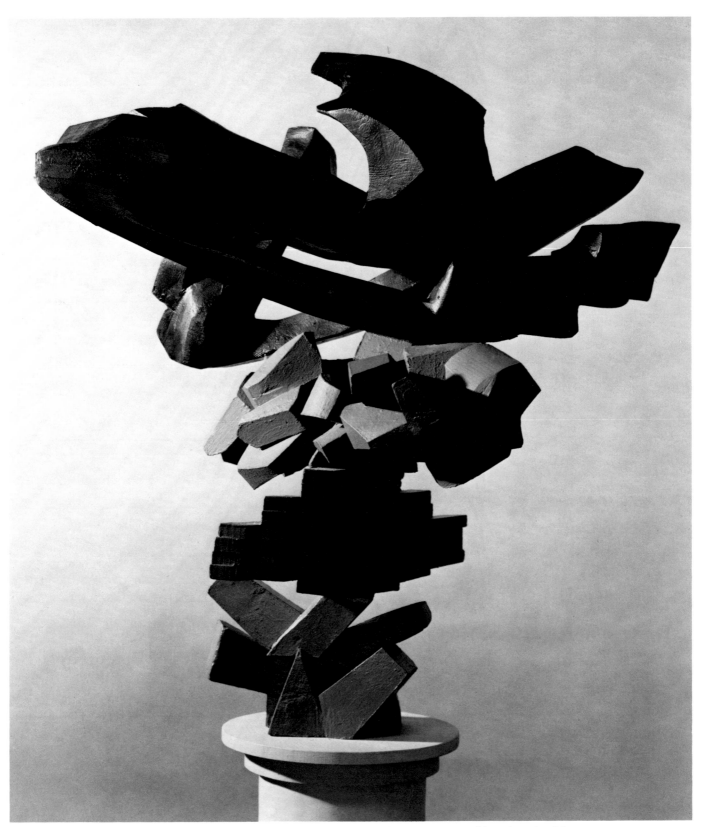

16. *Criss-Cross*, 1963, polychromed wood, 41 x 34 x 37. Whitney Museum of American Art, New York, Lawrence H. Bloedel Bequest, 1977.

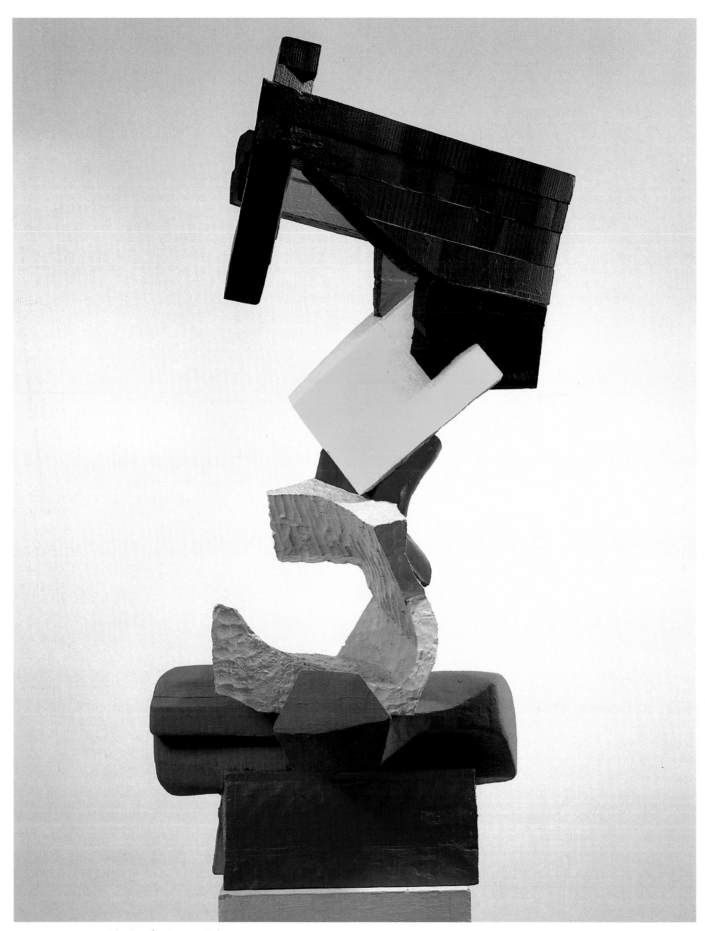

13. *One for Ornette Coleman*, 1961

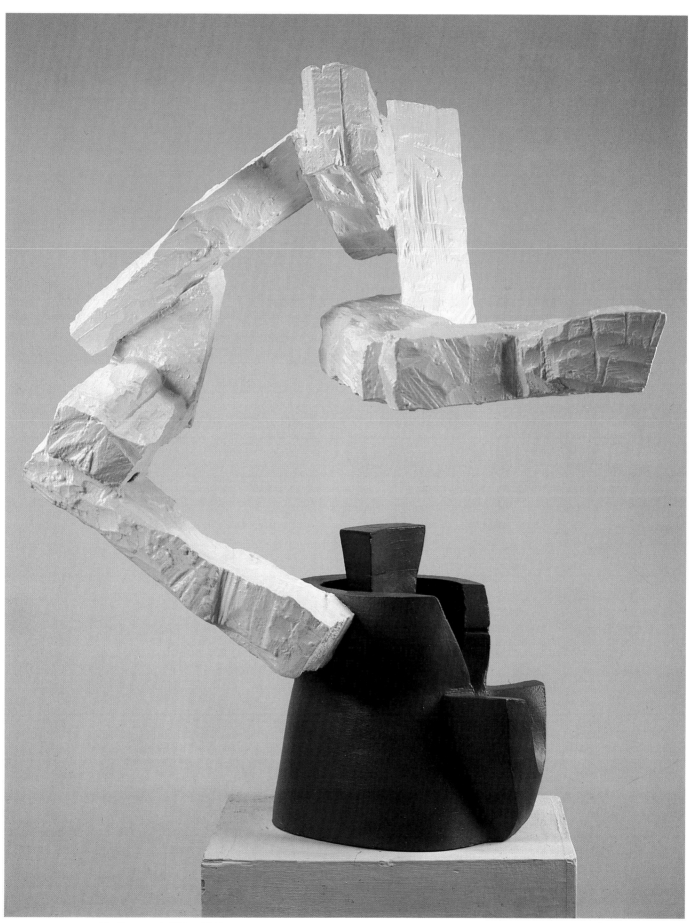

14. *Green and White*, 1962

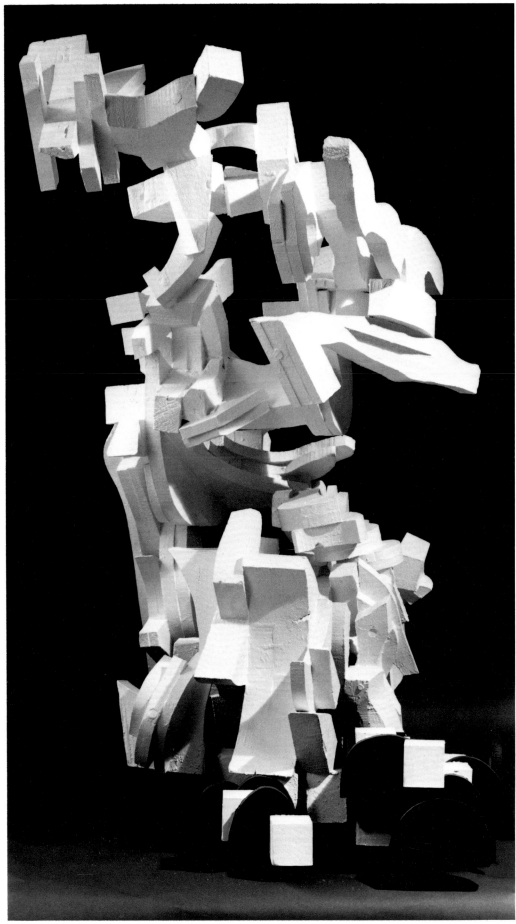

17. *Fugue*, 1963, polychromed wood, 64 x 43 x 54. Museum of Fine Arts, Springfield, Massachusetts, Museum Purchase with the Aid of the National Endowment for the Arts.

giving the spectator a clue to a more ultimate relationship than that implied between each of the individual forms.[28]

Thus, as Sugarman says, "More than other artists, I deal with existential disorder of life, attempt to order it. I almost illustrate it."[29]

In his next major multipart floor sculpture, *Two in One*, Sugarman expanded the ideas of *Inscape*, with an emphasis on the role of discontinuity and dissociation in sculpture, by physically as well as visually separating each form in the continuum.[30] As he says in his notes: "*Two in One* has reference to the continuous-discontinuous, wave-particle nature of matter."[31] It is the first sculpture by Sugarman that is environmental in the sense of inviting the spectator to walk through as well as around it: the piece cannot be encompassed by one glance of the eye. Amy Goldin, one of Sugarman's most ardent supporters, describes the diverse experience of viewing a Sugarman sculpture as being completely at odds with the gestalt idea of the total object that Minimalism espoused.

> If you move to the right or the left, the whole profile changes, the center of gravity shifts, the forms change their functions. A different view gives new information in no way deductible from the old . . . The continued transformations and oppositions of both form and feeling are what make Sugarman difficult.[32]

Two in One's V-shape, where two lines of thought develop from the "seed"[33] form at the point of the V, suggests the title. The nature of the forms, however, reveal a more metaphorical meaning to the work than the title suggests. The forms emerging from one side are lower, more organic and more delicate. The other side's forms are taller, more

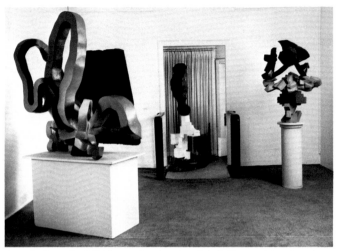

Installation of exhibition at Stephen Radich Gallery, 1964, showing (from left to right) *Black X, Ramdam,* and *Criss-Cross.*

geometric and bulkier. The forms parallel each other as they move away from the seed form in a male/female duality. Thus *Two in One* can be read as a metaphor for two schools of shapes in art — organic or geometric — or as a reference to the duality of existence on a metaphysical level.[34] The forms' concave and convex interconnections, like light plugs, also suggest a male/female duality. Each interval between forms is carefully calculated to set up a spark of energy across these gaps. Since each separate section is a different color and shape, Sugarman leads the viewer in a halting stop-and-start motion from one segment to another through a squeezing and releasing of visual tension analogous to the physical tension of a hand compressing and releasing a sausage-shaped balloon.

At this point, Sugarman realized that the size of his work had reached its indoor limit; therefore, if he wished to work even larger, he would have to

28. New York, New School Art Center, *The Artist's Reality: An International Sculpture Exhibition*, 1964, n.p.

29. George Sugarman, GSP, (ca. 1967).

30. Henry Moore separated his female forms into separate pieces, but the pieces or parts were meant to be viewed as a related whole, unlike Sugarman's idea of "endless continuum" or "field" sculpture.

31. George Sugarman, GSP, undated.

32. Amy Goldin, "The Sculpture of George Sugarman," *Arts* 40(June 1966):29–30.

33. "Seed" is Sugarman's descriptive term.

34. Sugarman underlined the following passage in Ronald Steel's review of *The Society of Man* by Louis Halle in *The New Republic*, May 14, 1966, p. 28: "We necessarily live in two disparate worlds: a chaotic existential world and a conceptual world of order . . . The result is a dualism which forces us to inhabit two worlds simultaneously: a world of ideas and a world of 'facts' — a world of conceptual order and a world of continually changing realities . . . The two worlds continually approach and drift apart, but never become one."

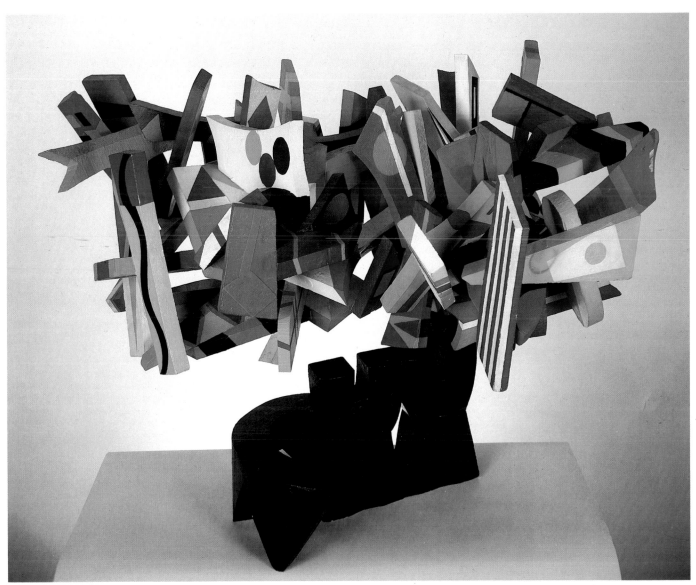

15. *Axum*, 1963, polychromed wood, 35 x 38 x 49. Helen F. Spencer Museum of Art, The University of Kansas (Gift of the National Endowment for the Arts and the Friends of the Art Museum)

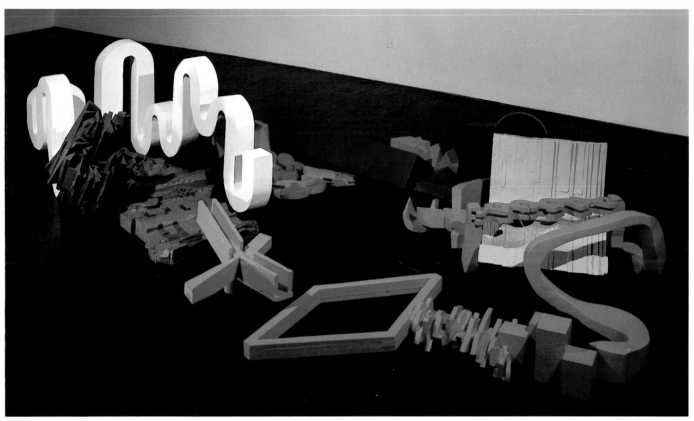

20. *Inscape*, 1964

change his medium to metal so that his work could go outside and so that the physical labor of making the work would not be so exhausting. Toward this aim he began to simplify his forms and work in modules. His surfaces also became less expressionistic.[35] As mentioned in Brad Davis' recollections, Sugarman now relied completely on his assistants to build the work which he described verbally to them as they progressed. This method is alien to Minimalist procedures in which artisans fabricate pieces from models and drawings. The assistants became Sugarman's hands in a very direct way and allowed him to make pieces that would not have been physically possible if he had been working alone.

In the next two years, Sugarman completed in wood the monumental works *Two Fold* (1968), *Threesome* (1968–69), and *Yellow to White to Blue to Black* (1967), as well as several smaller sculptures such as *Yellow and White* (1967) and *Adirondack* (1967–68). All are more regular in shape, smoother surfaced, and painted in more subdued colors than previous work. The culmination of these large wooden pieces was *Ten* (1968–69).

Ten, like *Two in One*, uses a male/female imagery combined with the shell form that so interested Sugarman. The egg form on one end transforms itself to the lingam form of the other end. The progression from one to the other is complex and unpredictable. Unlike Sugarman's other works, the viewer cannot enter the enclosed space. Despite its symmetry and geometry, the feeling of *Ten*, like all Sugarman's work, is growing and expansive, rather than static and closed.

When these works and his early metal pieces, like *Square Spiral* (1968) and *Trio* (1969–70), came to be regarded as Minimalist works, Sugarman took exception. He made his objections to Minimalism clear in the following letter he wrote to Hilton Kramer about *Square Spiral*:

A point of information: Your inclusion of my sculpture *Square Spiral* among the minimal is inaccurate. Indeed, it challenges the minimal at almost every point in its aesthetic. Space, relationships and activity are dirty words to the minimalist. Certainly, my sculpture is active; certainly it is involved with, and involves the spectator in, a changing internal volume and a spatial experience. Certainly, as an outdoor piece, it is involved with the ever-shifting relationships that would come with the changes of light. And certainly it is dramatic, which no minimalist (Heaven forbid!) would allow. Whatever drama a minimal sculpture might have is internalized and not even in the sculpture itself but only in the spectator.

I believe strongly that less is less and that more, while not always achieving it, has at least a chance of being more.[36]

Perhaps the most important feature underlying all of Sugarman's work is structure. Consequently superficial stylistic appearances which associated Sugarman with any group of artists, such as the Minimalists, were particularly abhorrent to him. To understand the structure of the art or the universe was to understand its reality. Structure was formulated on relationships, style on appearances. So, if the object had no inherent structure, then it was merely an object, not art. As Sugarman put it in his notes:

Science, like art, deals with structure. Scientific discovery is made by the analysis of relationships, of structure. Science is concerned with its *form* as a body of knowledge and as a method.[37]

Thus the wooden and early metal works of the late sixties were not Minimalist objects, but rather investigations of structure and, in particular, the structure of inside/outside relationships. They progress from form to form in *Yellow to White to Blue to Black* as well as within single forms. The development of those permutations from inside to outside was to continue throughout the seventies, when Sugarman abandoned wood for metal in his public sculpture.

35. Interview with George Sugarman at the artist's studio (unpublished) New York, 13 February 1981.

36. George Sugarman, letter to Hilton Kramer, GSP, 17 December 1968.

37. George Sugarman, GSP, undated.

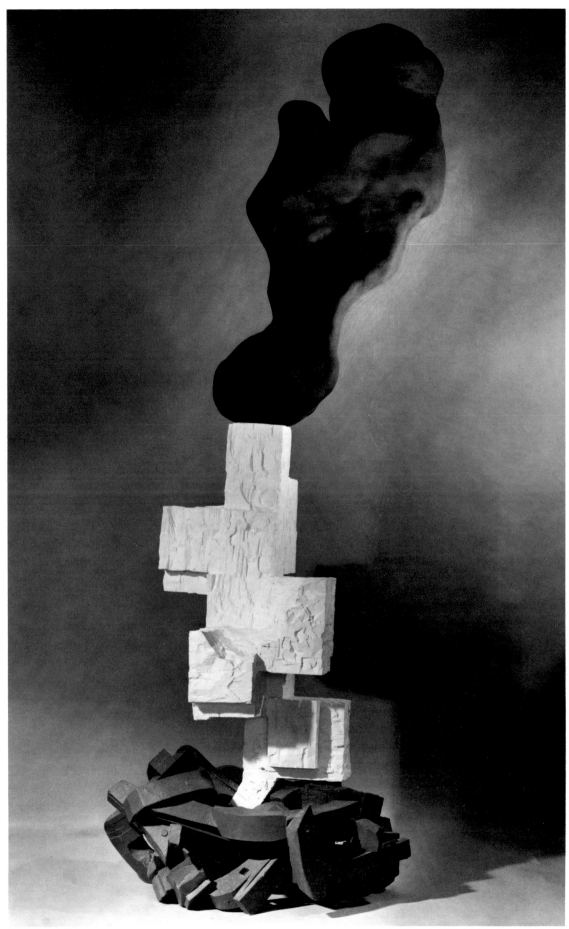

18. *Ramdam*, 1963, polychromed wood, 122 x 48 x 48 (approximately). Mary and Leigh Block Gallery, Northwestern University, Gift of the Estate of the late Robert B. Mayer and Mrs. Robert B. Mayer.

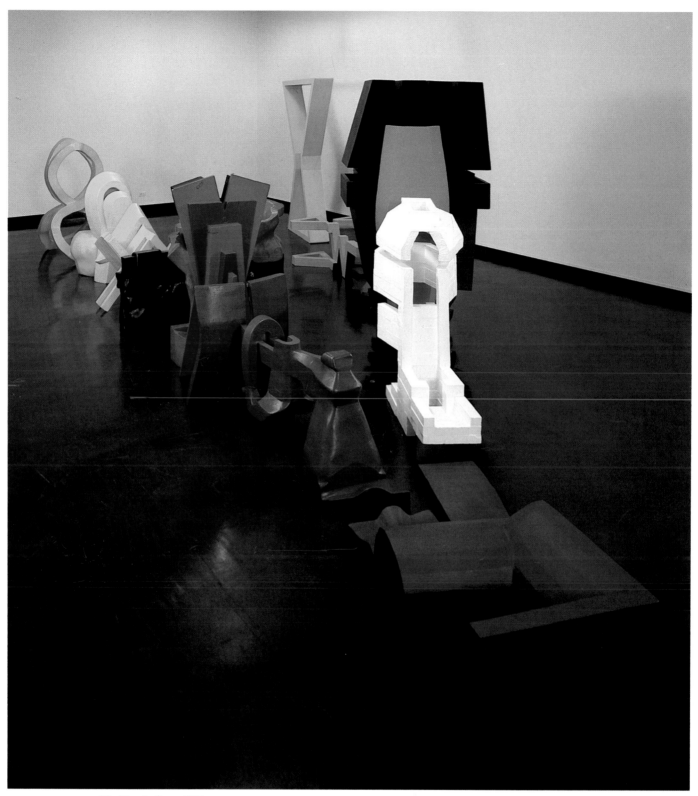

23. *Two in One*, 1966

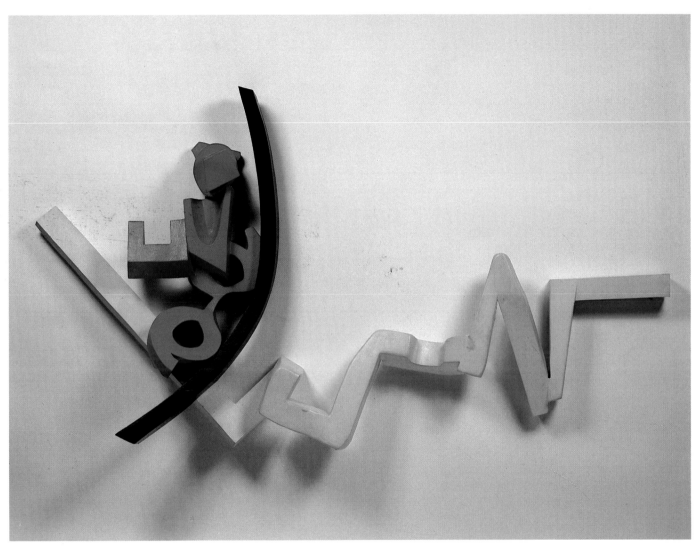

24. *Untitled Wall Relief*, 1966–69

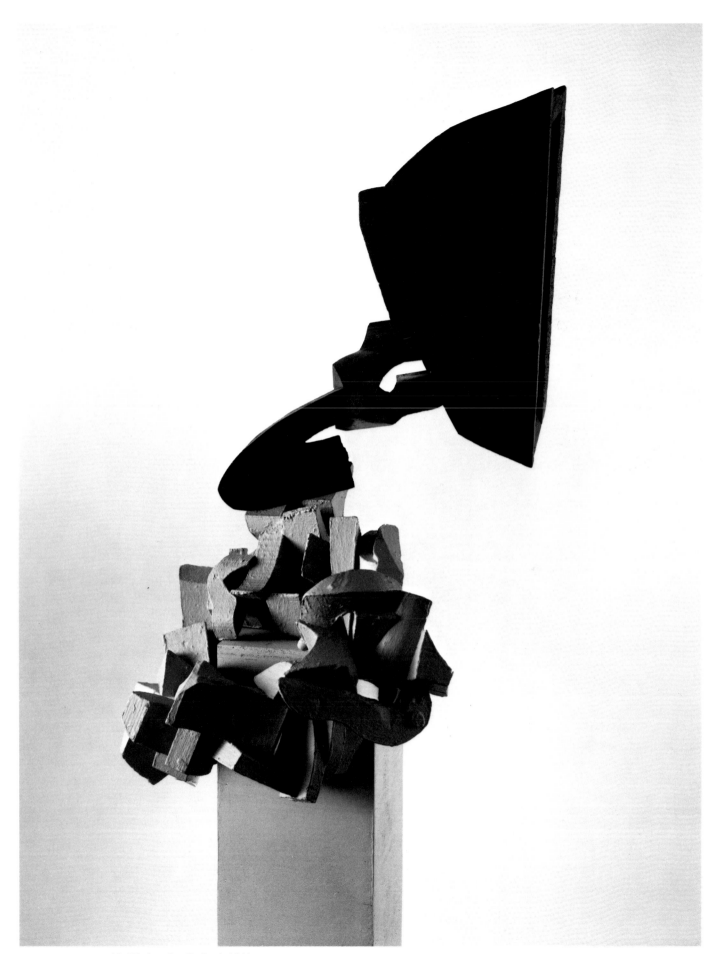

19. *Black and a Garland*, 1964

Chapter IV

On a stark Baltimore city plaza rests a great blue and yellow gazebo, a haven in a sea of concrete buildings, Sugarman's *People Sculpture*. How ironic that this lacy arbor, a General Services Administration (GSA) commission of 1975 for the new federal courthouse, should have caused such controversy, for Sugarman believed that public sculpture should be enjoyed by the masses as well as the elite. He made a distinction between public and private art.

> There are two different art contexts — one having to do with public life, the function of buildings, the movement of people, and their comfort as well as their aesthetic enjoyment. The other context is the gallery and museum situation, where audiences may not understand but their minds work within that context — that audience that cares more for beautiful and aesthetically realized objects.[1]

Unlike many artists of the seventies, Sugarman felt that public sculpture should not intimidate a person but look inviting. He hoped that colors, the lacy metal forms, and the referential elements of trees and arbors would help the public identify with his sculpture.

Unfortunately the judges, particularly federal Judge Northrop, considered the sculpture not a gazebo for a noontime sandwich, but a "potential shelter for persons bent on mischief or assault on the unsuspecting," as well as a potential hiding place for bombs and a platform from which dissident groups could speak or hurl objects.[2] Although Sugarman stated he had "never heard of death by sculpture,"[3] he presented a modified, more open sculpture to the judges on March 25, 1976, but to no avail. "If anything, the model of Mr. Sugarman's revised concept is even more unacceptable than the original one,"[4] wrote Judge Northrop. Only after numerous letters from GSA and Artists Equity did the Commissioner of the Public Building Service approve the sculpture in October 1976. John Blair Mitchell, president of Artists Equity, writing to Mr. Eckerd, an administrator of GSA, made the following most forceful argument on behalf of the sculpture:

> If the sculpture is a natural place for a bomb, doesn't this make it easier to find (rather than having to search every toilet and basement in the area?) . . . What I am saying is that the sculpture . . . is a neutral object like a tree — it can provide shade or gallows . . . is it not strange to select this one which is made to bring joy . . . for all these hostile projections suggested by the Judge?[5]

The notoriety this Baltimore commission engendered drew attention to the seemingly vast change in Sugarman's work since he had made the austere *Ten*, one of his few works regularly on public view in New York. In the ten years from Sugarman's first public commission in 1967 for Max Palevsky until

1. Paula Harper, "George Sugarman: The Fullness of Time," *Arts* 55(September 1980):160.
2. Edward S. Northrup, letter to Senator J. Glenn Beall, Jr., 1 April 1976, printed in "Public Art vs. Public Safety," *American Artist* 40(December 1976):8.
3. JoAnn Lewis, "People Sculpture: Objects Overruled," *Art News* 77(December 1976):84.
4. Northrup, "Public Art vs. Public Safety," *American Artist* 40(December 1976):8.
5. John Blair Mitchell, President of Artists Equity, letter to Mr. Eckerd, Administrator of GSA, 7 July 1976, printed in "Public Art vs. Public Safety," *American Artist* 40(December 1976):9.

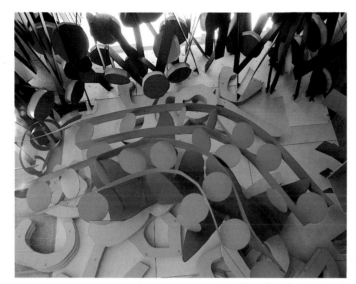
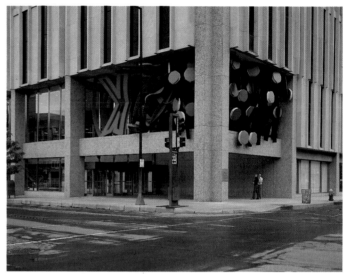

St. Paul Commission, and ceiling detail (right), The First National Bank of St. Paul, Minnesota.

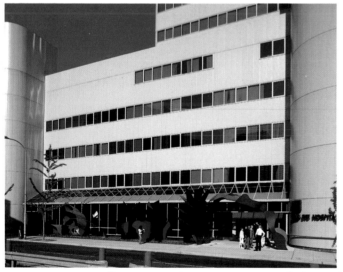

Will's Eye Hospital Commission, 1981, polychromed aluminum. Collection of the Will's Eye Hospital, Philadelphia. Photo: Eugene Mopsik.

the final installation of *People Sculpture* in 1977, Sugarman not only responded to the times and sculptural ideas of the sixties, but also developed his own philosophy of public sculpture and a method of working with sheet metal that was uniquely his.

The new skyscrapers burgeoning in every American city with the prosperity of the late sixties created a demand for large outdoor sculpture to enhance the plazas which accompanied these new buildings. This need coincided with a proliferation of artists engaged in making monumental sculpture. Although the Abstract Expressionist painters made mural-size paintings, the sculptors of their generation, like David Smith, did not respond in comparable size and mass until much later. Calder had an exhibition at Perls Gallery in 1958 of fairly large stabiles. Giovanni Carandente, assistant director of the Museum of Modern Art in Rome, organized an outdoor sculpture exhibition in Spoleto in 1962 which included Calder's stabile *Teodelapio* and David Smith's *Voltri Series*. Calder's, but not Smith's, was truly monumental: it actually spanned a functioning Spoleto roadway. But by the time of the Los Angeles County Museum's watershed show, "Sculpture of the Sixties" (1967), sculptural concepts had caught up with the growing demand for monumental public works. The models were there to be fabricated in large scale with the support of government[6] and corporate patronage for outdoor plazas and parks.

Sugarman's early outdoor commissions followed the concept of sixties public sculpture that any large-scale, durable metal sculpture was a public sculpture. His first outdoor commission came from Max Palevsky. In 1967 Amy Goldin brought Max Palevsky to Sugarman's studio, where he was building the wooden field sculpture *From Yellow to White to Blue to Black*. Palevsky, looking for a large outdoor work for the new Xerox building in El Segundo, California, commissioned Sugarman to build an enlarged version in metal for the plaza. At that time no American fabricator could make such

People's Sculpture, 1976, polychromed steel. Baltimore Federal Center.

complex forms, and Sugarman used a Dutch firm. In 1967, Donald Lippincott and Roxanne Everett founded Lippincott, Inc., in response to the growing need for a U.S. company devoted solely to the fabrication of large metal sculpture. Soon afterwards Donald Lippincott came to Sugarman to commission another outdoor work, *Square Spiral* (1968). *Square Spiral*, like a slightly later work, *Trio* (1969–70), is a single color, yellow, and predicated on a geometric variation of a single shape. In *Square Spiral*, as in *From Yellow to White to Blue to Black* and *Green and White Spiral* (in this exhibition), Sugarman explored the interior volumes of shell forms, using shapes simple enough to be easily fabricated with sheet metal. Although *Square Spiral* might tempt children to climb into its interior and *From Yellow to White to Blue to Black* is adapted to the plaza space, neither work particularly addresses any issue of public sculpture other than scale and durability.

The issue of what makes a sculpture appropriate to a public space, Sugarman realized, was much more complex than size alone. Stimulated by the idea of "field" sculptures that occupied the space of a

6. In 1967 the city fathers of Chicago erected the gigantic Picasso corten steel sculpture on the Civic Center plaza and the National Endowment for the Arts' "Art in Public Places" program approved its first grant of $45,000 commissioning Alexander Calder to make a design for a large public sculpture for Grand Rapids, Michigan. *La Grande Vitesse* was dedicated in June 1968. Both sculptures became icons for their respective cities. By June 1974, the NEA had approved eighty projects in twenty-seven states.

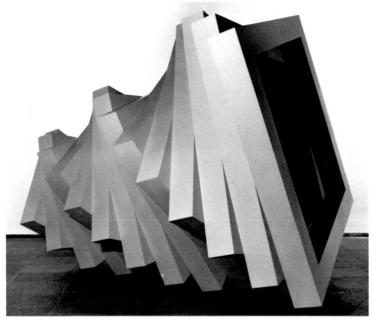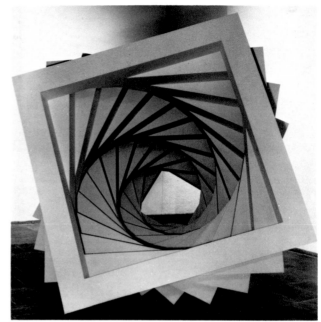

Square Spiral, 1969, painted steel, 96 x 120 x 132 (approximately). Collection of the artist and Lippincott, Inc. Photo: John A. Ferrari.

room, Sugarman began to think about the way outdoor works related to their environment, which was "not only buildings but people and their relationship to the work of art."[7] In this endeavor his friendship with critic Amy Goldin provided a forum for the discussion of ideas. Goldin's friendship with Sugarman began when she admired *Ramdam* in an exhibition and reportedly said, "I want to meet the artist who can make anything as 'crazy' as that."[8] In the sixties Goldin wrote some of the most astute articles on Sugarman's work.[9] Later the stimulus of Sugarman's ideas helped form her initial interest in and thinking on both decorative and public art. Goldin wrote a series of articles in the mid-seventies on both public art and the decorative which detail many of the precepts on those subjects now current in the art world. Goldin wrote that public art must not only solicit a wide audience and deal with a recognizable subject matter, but also must address

"its audience as participants in a public world."[10] The social implications of sculpture became increasingly important for Sugarman as he made the works that led up to the *People Sculpture* in Baltimore.

Sugarman first broke away from the trends of the sixties with a commission for the First National Bank of St. Paul.[11] Instead of making a large-scale abstract steel object which ornamented a building like a brooch, Sugarman attempted to answer for the first time "What kind of sculpture is appropriate to a public space?" by involving the public as they entered the building. The St. Paul commission relates to the architecture in an unusual way, for it hangs from the ceiling of the entrance, some thirty feet off the ground, or rather it fills an overhead area (20' x 32' x 46') with nineteen tons of sheet aluminum. The multicolored forms sprawl through the space and extend on the open sides out toward the street. Extension into space is no longer merely a formal

7. George Sugarman, Sugarman Statements (SS), New York: Robert Miller Gallery, undated.

8. See Brad Davis' Recollections in this catalogue.

9. Amy Goldin, "Beyond Style," *Art and Artists* 3(September 1968) and "The Sculpture of George Sugarman," *Arts* 40(June 1966).

10. Idem, "The Esthetic Ghetto: Some Thoughts About Public Art," *Art in America* 32(May/June 1974).

11. Following *Two in One* (1966), Sugarman was a guest artist at Hamline University in St. Paul and St. Cloud State University in St. Cloud, Minnesota. Through the efforts of Martin Friedman, Sugarman received a commission for the entrance of the First National Bank of St. Paul in 1968.

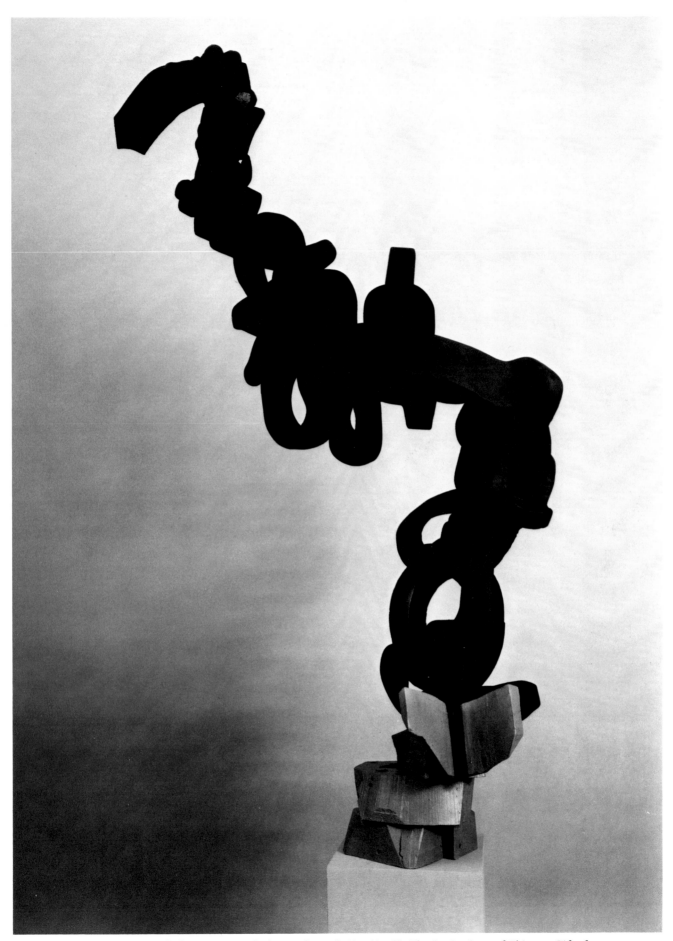

21. *The Shape of Change*, 1964, polychromed wood, 61 x 49 x 23. The Art Institute of Chicago, Gift of Arnold Maremont.

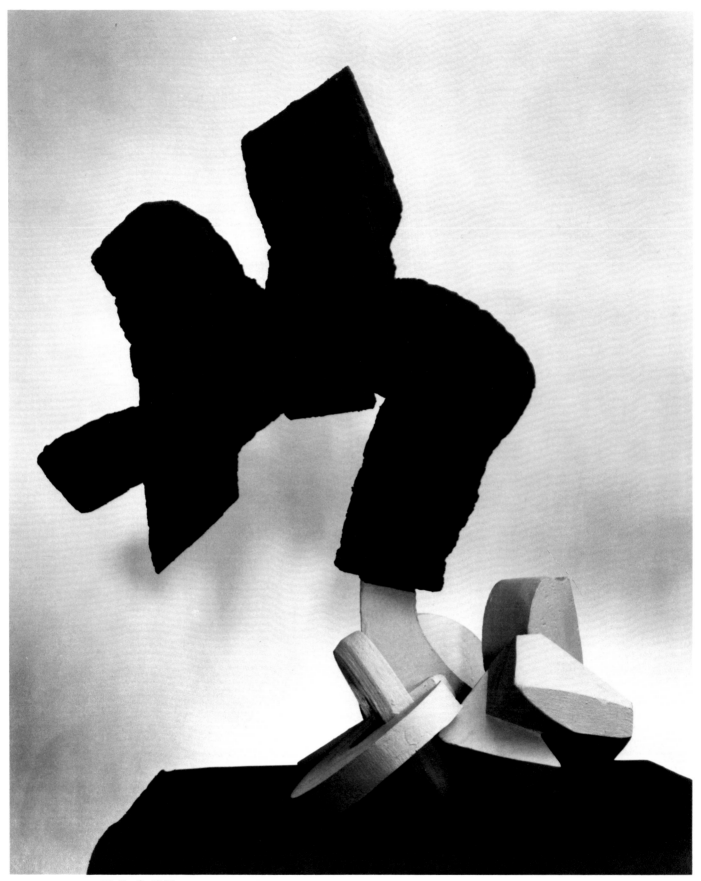

22. *Rorik*, 1965

innovation but serves, along with color, to lure the passer-by into the building. The enticement recalls that of Louis Sullivan's famed corner entrance to the Carson, Pirie, Scott building in Chicago.

Sugarman adapted his formal ideas to the sheet metal rather than having the metal imitate wood, as it did in *Trio* and *Square Spiral*. The flat cut-outs of aluminum forms are grouped by their "family" into stacks or series. The repeated shapes expand through slight displacements much as a deck of cards is fanned. Sugarman's expansions burst from their boundaries. Just as *Two in One* appears to continue endlessly, the St. Paul ceiling seems to be bound only by the walls rather than its composition. Even the walls cannot contain the sculpture, for it extends beyond them into space.

The use of flat metal shapes in a variety of uninflected colors inevitably draws comparison with Matisse's cut-outs. Although Sugarman does not consider him a major influence, as he does Davis and Leger, similarities occur. Sugarman expanded his work beyond the confines of a given architectural space in the St. Paul commission, much as Matisse extended the boundaries of the architectural frieze in his work, *The Swimming Pool*. Like Matisse, he used color for its emotional effects and its structural qualities in space. Also like Matisse, Sugarman was interested in parallels between art and music.

Following the St. Paul commission, Sugarman worked on a number of free-standing sculptures, which he showed at Zabriskie Gallery and Dag Hammarskjold Plaza in 1974, five years after his last exhibition at Fischbach. Many of these works were both moderate-size models for outside sculpture as well as works in their own right. Although designed as public sculpture, their interest lies more in their use of sheet metal for the exploration of motifs and themes than in their "publicness." The most complex and experimental work in this group was *Concord*[12] (1974), where the shapes are lapped together to make irregular chains. The "families of forms" interweave to form an energetic volume. The result is quite complex and messy in a photograph, but becomes intelligible in actuality because the viewer can peer inside.

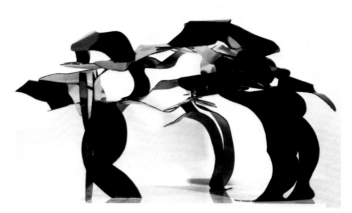

A Gathering Place, 1978–79, polychromed steel, 34 x 60 x 50. Collection of the artist.

As sculptural form, *Concord* continues the earlier theme of the shell form. The interior volume articulates the exterior, but unlike the dense wooden forms that were hollowed out or articulated in broken segments, *Concord* resembles a tree or bush. The metal, plate-like leaves on a tree make visually dense, solid forms from the exterior even though the leaves or "metal forms" are not dense and the interior space is airy. This interior volume created by vegetative forms later becomes the basis for many public sculptures, including his *People Sculpture* in Baltimore.

Consequently, what began as a pragmatic change of medium fulfilled itself through Sugarman's appreciation of the possibilities of the material. His statement about the Zabriskie exhibition sums up his intent:

> My choice has been not to eliminate but to keep all possible sources of meaning open. *Open* is a word I like. I like its idea. *Complexity* is another. Complexity is not merely enrichment but a means of opening up avenues to understanding and experience. My sculptures are meant to give, literally and figuratively, more than a one-dimensional experience. They will close themselves off to any one-level approach. I tend to think of them as meeting places where forms invented to please the visual imagination find their right colors and are organized into a space that invests them with their most suggestive relationships. A meeting place attracts diversity; diversity often means activity as one form or one color tries to be dominant, but a rigorous formal relationship throughout keeps each element in its place while allowing it its maximum assertiveness.

12. Sugarman intended this work to be twice as large as its 8′ x 7′ x 5′ dimensions.

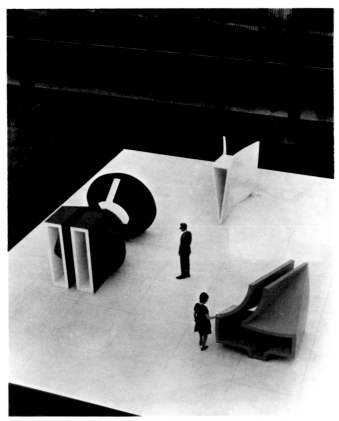

Yellow to White to Blue to Black, 1967, polychromed steel,
90 x 420 x 420. Xerox Corporation, El Segundo, California.

Relationship is obviously a key area and basic to it is a theme that runs through all the sculptures (the wall piece excepted), giving unity to work done over a period of years in which change from relative simplicity to greater complexity is exhibited. This theme is the creation of an internal volume by a thin, almost shell-like form. In each sculpture the volume finds a different expression as forms and colors surround it, pierce it, echo it to create a formal 'logic,' a logic which in turn supports and enhances the resonance of the metaphor.[13]

Sugarman's formal interest in internal volumes, his desire to entice the public to participate in his

sculpture and his increasing fluidity in using sheet metal led quite naturally to the architectural nature of the Baltimore commission, as well as to such models as *A Gathering Place* (1978) and *Sculpture in Relationship to Architecture* (1979).

In the climate of the seventies, favorable to non-Western and vernacular architectural ideas, Sugarman's long-time love for Islamic and Baroque architecture was understood in a way not possible in the sixties, when International Style architecture and Minimalism dominated aesthetic thought. In the seventies a group of younger artists, such as Donna Dennis, George Trakas, and Siah Armajani, discontented with immense metal sculpture on corporate plazas, built "structures" using a vernacular architectural vocabulary. These structures, often of a less permanent material than steel, usually found their home in the country, not the city, and often were intrinsically connected to the natural environment.[14]

Although Sugarman was not part of this group of artists nor an influence on them, the proliferation of such work (between 1974 and 1978)[15] made Sugarman's work seem much more a part of the times than the work of artists who continued to make large metal sculpture of a non-participatory nature. Perhaps Goldin was thinking of Sugarman as well as Matisse when in her 1975 article she said Matisse "aimed" at creating a sense of well-being and expanded, intensified space, a space in which the human feels in harmony with his environment. That is, "the work elicits a public and social experience rather than a private and intimate one," for he (Matisse) turned "the personal art-box into an open gazebo . . . that anyone can enter."[16]

13. George Sugarman, *George Sugarman* (pamphlet), New York: Zabriskie Gallery, 1974, n.p.
14. The Walker Art Center's catalogue for the exhibition "Scale and Environment: 10 Sculptors," (October 2–November 27, 1977) chronicles this interest, as do two smaller catalogues by Holliday T. Day, *Prairie Structures*, Chicago: DePaul University, 1979, and *Dennis Kowalski*, Chicago: N.A.M.E. Gallery, 1980.
15. Exhibitions at ArtPark in Lewiston, New York, between 1974–1978 were devoted to these artists.
16. Amy Goldin, "Matisse and Decoration: The Late Cut-outs," *Art in America* 63(July/August 1975):56, 58.

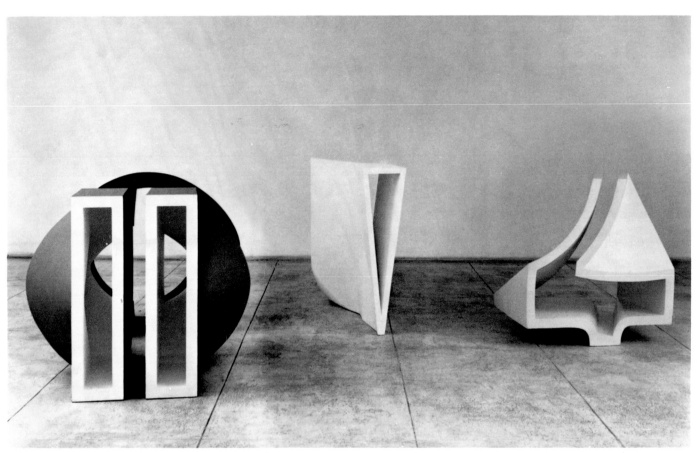

25. *Yellow to White to Blue to Black*, 1967

26. *Untitled Wall Relief*, 1968

Chapter V

In 1976 Sugarman participated in the important exhibition "Ten Approaches to the Decorative" at Alessandra Gallery with a group of mostly unknown artists, many of whom were thirty years his junior.[1] Sugarman's appearance in the show allied him with artists who espoused the pursuit of sensual pleasure as a legitimate end of art and who through their work attacked the prevailing distinction between high and low art. Yet only a short time later Sugarman made the statement, "Calling my sculpture decorative is utterly ridiculous to me."[2]

This anomalous situation demonstrates once again Sugarman's role as the quintessential maverick. For as always, his involvement with current artistic thought was early and influential, but not straightforward. He defended the value of the decorative but denied it as a determining aim for his own art. Nevertheless, his work has been both an inspiration to and influenced by the decorative artists.

Robert Kushner first saw Sugarman's work in 1970.[3] At the time both he and Kim MacConnel were studying at the Univeristy of California in San Diego. One of his teachers there was Amy Goldin, who took him to meet Sugarman on a trip to New York. Kushner recounts how totally amazed he was at the roomsize model for the *St. Paul Commission* Sugarman was making in his studio on Greene Street.[4] Accustomed to the formal, rather colorless art taught in art school, he could not believe Sugarman could justify the work. However, as he saw the artist rework part of the model, Kushner realized that there was a rationale for everything, each part clearly occupying a determined position in space. For a young artist like Kushner to see that flamboyance, color, and complexity could have an intellectual and formal rigor equal to that of the most austere Minimalist work must have been similar in effect to Sugarman's own discovery of the great Baroque movements in Europe.

One of the interests Sugarman shared with Amy Goldin and his former assistant Brad Davis was Islamic architecture. In the late sixties as he began to think about larger public sculptures, he particularly appreciated the Islamic integration of pattern with architecture to create a sensuously appealing environment. Amy Goldin eventually carried this interest much further. She took courses in Islamic art at Harvard under Oleg Garbar, and when in 1974 she received a critic's travel grant from the National Endowment for the Arts, she went to Iran to study Islamic architecture. For part of the trip, Robert Kushner accompanied her for a first-hand look at some of the world's most superb decorative artworks.

1. Sugarman participated along with Joyce Kozloff, Valerie Jaudon, Robert Zakanitch, Barbara Zucker, Brad Davis, et. al.
2. George Sugarman, Sugarman Statement (SS), November 1978, New York: Robert Miller Gallery.
3. Telephone conversation with Robert Kushner, June 1981.
4. See Ruth Meyer's excellent histories of Kushner and other artists involved with the decorative in *Arabesque*, a catalogue for an exhibition of the same name held at The Contemporary Arts Center, Cincinnati, Ohio, in 1978.

27. *Ten*, 1968–69, polychromed wood, ten parts, 91 x 149 x 71 installed. The Museum of Modern Art, New York.

Harold and Hester Diamond and Mrs. Joseph James Askton Funds, 1976.

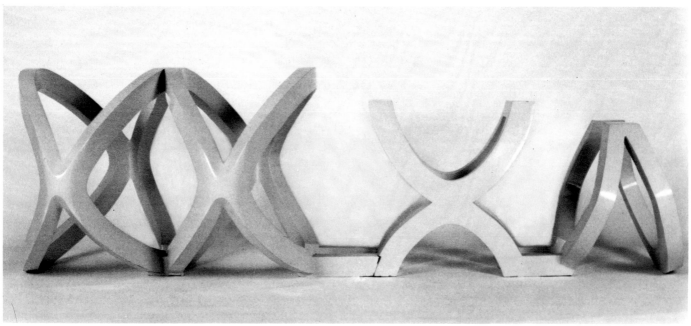

28. *Trio*, 1969–70

The result of Goldin's studies was a series of articles between 1975 and 1978[5] in which she articulated her concepts of Decorative art's meaning and structure. These can be roughly summarized as follows:

(1) Decoration is a different kind of aesthetic experience from "high" art. Both are equally valid and intellectually demanding.

(2) "High" art is the locus of spiritual experience transmitted by visual means and is private in contrast to decoration, whose aim is pleasure and delight of the senses and is public.

(3) Decoration aims at a unified environment extending into the space it commands, not at projecting a unified vision into an isolated whole, such as easel paintings.

(4) Decoration is defined by its structure rather than imagery. It stresses the structural importance of interval, pattern, grids, and frame/field relationships. Other important features are color and complexity.

These articles were pivotal in focusing interest on the decorative[6] as it appeared in past art forms and as its underlying concepts opened up viable avenues for contemporary artists to explore. Along with articles by Joseph Masheck and John Perreault,[7] Goldin's essays helped overcome the pejorative sense the word decorative had in the sixties.

While Sugarman could agree with Goldin's definition of the decorative, he claimed multiple meanings for his own work, saying, "Metaphor, stimulation (i.e., decoration's sensual appeal), formal relationships, are three ways to meaning. Is it necessary to choose?"[8] Thus Sugarman's belief in the inclusive and conglomerate nature of the world could support his participation in decorative exhibitions without

Venus Garden, 1970, polychromed aluminum, 108 high. Collection of Max Palevsky.

compromising his position that his own work was not "decorative."

The works which seem to ally Sugarman most closely to the decorative movement were his reliefs made during the early 1970s. In 1969, after Sugarman's retrospective in Europe, he was left without an assistant and used Lippincott to fabricate his work in metal. As he was no longer actively building sculpture in his studio, Sugarman turned to drawing and also to making small three-dimensional cardboard sketches. The drawings, actually paintings on paper, were dense, complex multi-hued patterns of bold forms, sometimes consisting of repeated gestural brush marks, at other times resembling the cellular shapes one might see under a microscope. In either case they were very free, with large bold forms quickly rendered. The three-dimensional cardboard sketches were not always complete models for metal works, but fragments which Sugarman tacked to his studio wall.

5. "Pattern and Print," *The Print Collectors Newsletter* 14 (March/April 1978); "Matisse and the Decorative: The Late Cut-outs," *Art in America* 63 (July/August 1975):49–59; "The Body Language of Pictures," *Artforum* 16 (March 1978):54–59; "Patterns, Grids and Painting," *Artforum* 14 (September 1975):50–54; "Islam Goes to England," *Art in America* 65 (January 1977):106–113.

6. Symptomatic of the interest generated in the decorative was *Art in America's* issue devoted to Matisse in July 1975, the opening of the reinstalled Islamic wing at The Metropolitan Museum of Art in 1976, and exhibitions on quilts. In addition, the women's movement encouraged the validity of the decorative since traditionally Western women have played greater roles than men in making decoration.

7. Joseph Masheck, "The Carpet Paradigm: Critical Prolegomena to a Theory of Flatness," *Arts* 51(September 1976):82–109; John Perreault, "Issues in Pattern Painting," *Artforum* 16(November 1977):32–36.

8. George Sugarman, *George Sugarman* (pamphlet), New York: Zabriskie Gallery, 1974, n.p.

Greenfield School Commission, 1972, polychromed aluminum, 384 x 216. Collection of The Albert P. Greenfield School, Philadelphia.

This activity led Sugarman to make multi-part reliefs, designed for specific spaces, in which each part was a unit in itself — often gestural — but which interacted with the other parts to make a complex whole. Two of these, *Venus Garden* (1970), a commission for Palevsky's New York apartment, and a commission for the Greenfield School in Philadelphia, were fabricated in metal. A third was cut from paper and exhibited in 1974 at Zabriskie Gallery, along with his early metal sculptures. The forms of these reliefs suggested flowers and masks, lending a festive Baroque mood to the work — the antithesis of the less is more school.

The reliefs not only permitted Sugarman to be more ebullient in his gesture but also allowed him to work with the architectural space in an environmental way not always possible with free-standing works. The *Greenfield School Commission*, for instance, sweeps around three walls and two floor levels like a great flowering vine in a conservatory. The color, the plant-like and mask motifs, and the integration with architectural space were features of these works that appealed to those interested in the decorative. But for Sugarman the reliefs were a continuation of formal interests of the sixties in a different mode which allowed him more freedom of expression. The emotional and sensate attraction of the reliefs for the public as well as their decorative qualities added to but did not replace Sugarman's other interests. Nevertheless, the complexity and

energy of these reliefs, as well as early works like *Inscape* and *Two in One* which were exhibited in "200 Years of American Sculpture" at the Whitney in 1976, inspired a whole new generation of artists who saw that fragmentation, color, and pattern lent new possibilities to their own work, although their goals were quite different from Sugarman's. Work as diverse as that of Lynda Bengelis, Nancy Graves, Barbara Zucker, Ree Morton, Judy Pfaff, and Cynthia Carlson build indirectly and occasionally directly on Sugarman's example.[9]

The reliefs took a new direction when Sugarman decided to make some Christmas cards by cutting up some old paintings on paper. In the process of reassembling the shapes by pinning them to a wall, he realized a fragile relief. Intrigued with its possibilities, he attached them to a foamcore board and strengthened the edges with fiberglass to make his first "relief-collages," thus adding a new chapter to the long tradition of relief-collages that goes back to 1912. The layering of irregular organic shapes into open configurations recalls Arp's Dada reliefs of painted wood. However, while even Arp's most complex composition, *Plant Hammer* of 1916, has a harmonious presence, Sugarman's relief-collages with their painted surfaces refused to be bounded within finite limits and burst outward with centrifugal force. Sugarman's relief-collages combined the most painterly of painting with the sculptural form of the relief.

This new mode of expression not only provided a way for Sugarman to work in his studio during the fabrication of his large public work but gave him new latitude in expression. Unlike the relief at Zabriskie, the paper already had a gestural pattern on it. Treating the isolated brushstrokes as building units rather than using them for the traditional purposes of expressive form recognized the brushstroke's dual nature as a flat decorative unit and as an expressive carrier of information and emotion. Sugarman hung these relief-collages from white cord like a Japanese scroll, thus acknowledging both the relief's dependence on the wall for support and its independence as a sculptural object separate from the wall. Coincidentally, as John Cheim, director of Robert

9. Artists like Barbara Zucker, Ree Morton, and Cynthia Carlson met regularly in the early seventies to exchange ideas, many of which were inspired by Sugarman's example.

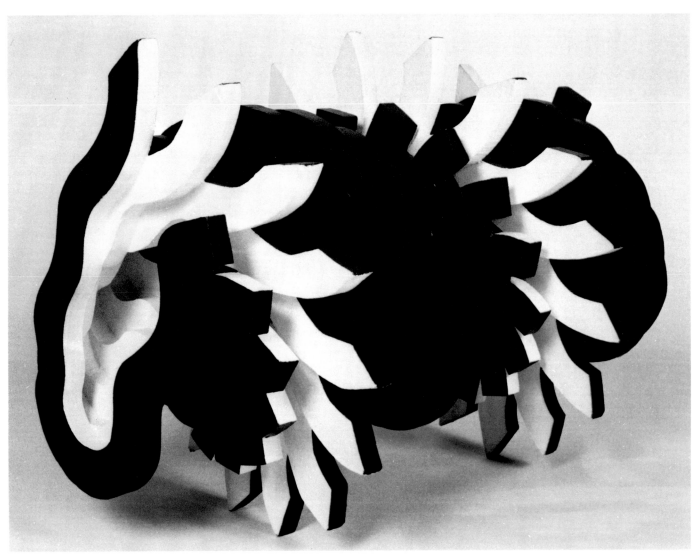

29. *Green and White Spiral,* 1970

Miller Gallery, pointed out to me, many of the exterior forms of the whole relief-collage resemble the very free Orientally inspired calligraphic drawings Sugarman made in black paint in the late fifties. The most recent relief-collages with their expansive gestural shapes exemplify that eccentric quality so characteristic of Sugarman's most interesting work.

For many, these new relief-collages when first shown at the Robert Miller Gallery in 1978 looked even more decorative than his previous reliefs because of their use of the spectacular color combinations so often associated with the great decorative traditions of the past. Consequently, Sugarman felt compelled to write a lengthy statement which pointed out those criteria of decorative art which his collages did *not* meet.

> As for the collages, you will see how few of the items fit them (i.e., the criteria for decorative art). The collages are too intense, either in emotion, or texture, or rhythm; they don't fit a frame (even the screens work in and out and against the frame); content, or subject matter, the abstract, is too strong. Emotional involvement is always asked for; pattern (as differing from repetition) is seldom used; contrasts are often strong; space is not flat especially in the later ones.[10]

If one accepts Amy Goldin's criteria for the decorative, one has to agree with Sugarman's analysis that his relief collages do not fit comfortably within this tradition. Nevertheless, his inclusion in Decorative exhibitions is not without foundation, especially when one considers the background of the Decorative movement in the seventies. Artists such as Joyce Kozloff and Valerie Jaudon sought to reestablish the value of the Decorative tradition by emulating in their paintings the elegant patterns and materials of the Islamic and Japanese cultures. Their efforts were reinforced by the rising women's movement because women have traditionally been active in making decorative objects such as quilts and clothing. At the same time, the decorative tradition, which they wished to revitalize, was tainted by commercialization. These artists faced the additional hindrance that many progressive artists of the New York School considered decoration an unsuitable pursuit for the serious artist. In their attempt to validate abstraction, they had deliberately left the role of decoration to the commercial designer. Commercialization had inundated society with insensitive adaptations of historic styles as well as with poorly designed objects of synthetic materials such as plastic, flock, and polyester. The stigma attached to this debased tradition posed a formidable barrier to the artist.

Consequently, in order to extricate the Decorative from its morass, some artists such as Robert Kushner, Brad Davis and Barbara Zucker, in a spirit of irony, borrowed kitsch motifs from twentieth century decoration. They developed a formal treatment of these materials that emphasized the temporary nature, eccentricity, and scale of decorative environments rather than pattern.

On the surface, Sugarman appears to have more common ground with this group which co-opted these ersatz materials than with the pattern painters. The quickly applied paint, the flimsy paper materials, the lavish color, and the festive subject matter are part of Sugarman's work as well as theirs. These similarities, coupled with the importance which Sugarman's rigorous formal control had for these artists, can account for his inclusion in the Decorative exhibitions. Nevertheless, the decorative elements in Sugarman's work, although integral parts of his formal vocabulary, are not ends in themselves but contribute to the exuberant character which dominates all his work.

More recently some younger artists, taking the example of the Decorative artists, adopted these materials mainly to exploit their formal qualities rather than their decorative nature. They found in Sugarman the type of formal means necessary for this adoption. The unpredictable additive mode without concrete boundaries, the emotional response to color, and the importance of change or motion have become trademarks of these young artists.[11] Consequently, the Decorative has been to-

10. George Sugarman, SS, November 1978, New York: Robert Miller Gallery, p. 2.
11. See Holliday T. Day's catalogue for the I-80 Series exhibition "Nancy Arlen, Richard Beckett, Dike Blair, Steve Keister, Steven Mannheimer, Tom Rankin, John Torreano, and Roxie Tremento" at the Joslyn Art Museum, November 15, 1980 through January 4, 1981, for a further discussion of these ideas.

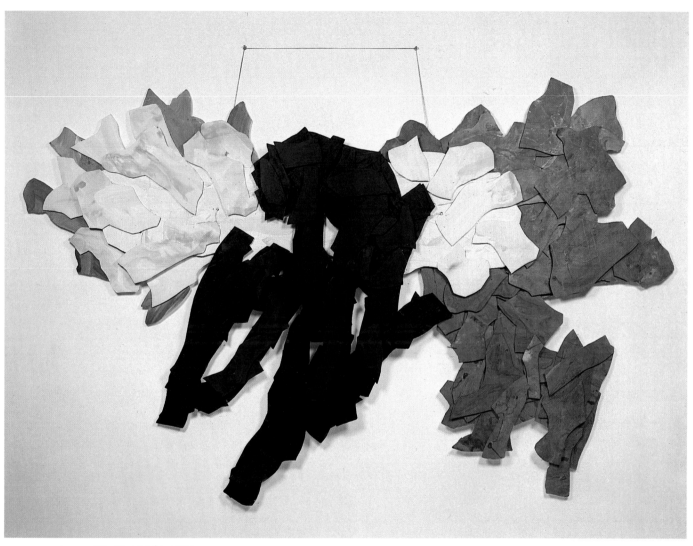

34. *First Light*, 1977

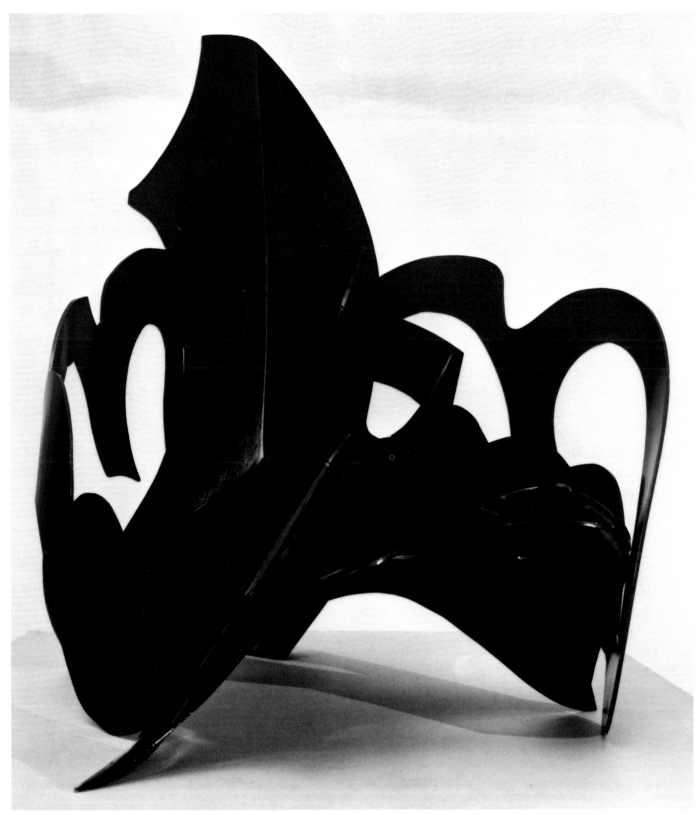

31. *Blue Circle*, 1974

tally absorbed into the mainstream of art even as it has changed its course.

While the relief-collages, drawings, models, and public sculpture occupied most of Sugarman's time in the seventies, he still found the energy to make some indoor metal sculpture out of thin aluminum sheets. They are strange and intriguing works. Some, like *Boundaries* and *Whiteside*, look like collapsed card castles after a battle between two paper knights. Others, like *One* and *Orange Around*, are cards falling like waves or rising in whirling vortices like tornadoes. Both suggest impending collapse as well as tremendous force driving the thin, irregular-shaped leaf-life forms that constitute the building blocks of these most recent sculptures.

Yet these works, complex to the point where each component has become like a brush stroke in a Monet painting, continue all those ideas worked out in the previous twenty years. The Cubist clusters of form families like *Bardana*, the Baroque interest in waves and waterfalls like *Ritual Place*, the low-lying sculpture rambling on the floor like *Inscape*, and the interior space of *Ten* and *Concord* all show up in the work of the late seventies and are articulated with great verve, color sense, and logic. In addition, the flat color modules combined with the emphasis on gestural motion give these works a mood not found before. Or as Sugarman says, "Complexity is something I like."[12]

Few other artists approaching their seventieth year continue to absorb new ideas and develop new techniques when they can rest on their past achievements. Sugarman, however, finds new means of expression for the existential fullness of life. He has more than made up for his late start in life as an artist by compressing a lifetime into thirty years.

EPILOGUE

When all is said and done about the rigorous formal qualities, the metaphysical strength, and the sensate appeal of Sugarman's work, there remains the mystery of why so many knowledgeable people have found it difficult to accept. Its contradictions, complexities, and untidy nature appear inept to those brought up on the accepted aesthetics of sculpture. His work does not yield easily to conventional analysis. But those aspects which initially look clumsy or out of control become the very parts one comes to love best. One begins to appreciate the rich personality which created these complex works. Sugarman's extraordinary range, fecundity, and receptivity to new ideas bring a rarely seen richness to his sculpture.

Perhaps the most fascinating and endearing aspect of his work is its elusive spirit. Words like wit, energy, or emotional zest attempt description of this spirit but, as in trying to explain a joke, the essence is lost. Brad Davis described it as a kind of funky awkwardness that made him laugh when he saw the profile of *Ten*. Amy Goldin found it in *Ramdam's* crazy potato-like form. For me it is the delicious ludicrousness that comes from teetering on the edge of excess — that extra piece about to topple or that eccentric shape balanced too far off center yet seeming to hold together — just barely. Perhaps it is the expression of the joy that comes from living life to the fullest; that is what Sugarman has done best.

12. Sugarman, New York: Zabriskie Gallery, 1974, n.p.

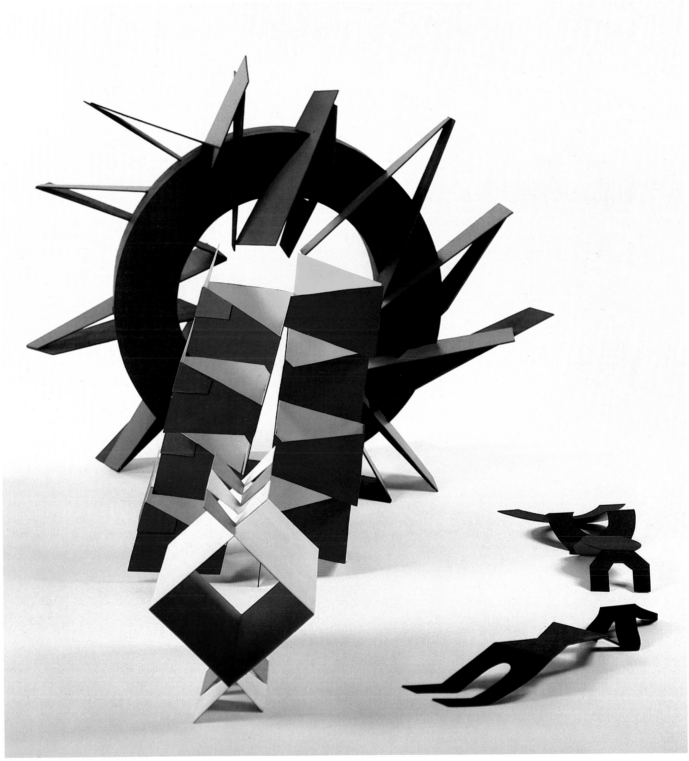

30. *Leverkusen Commission*, 1970

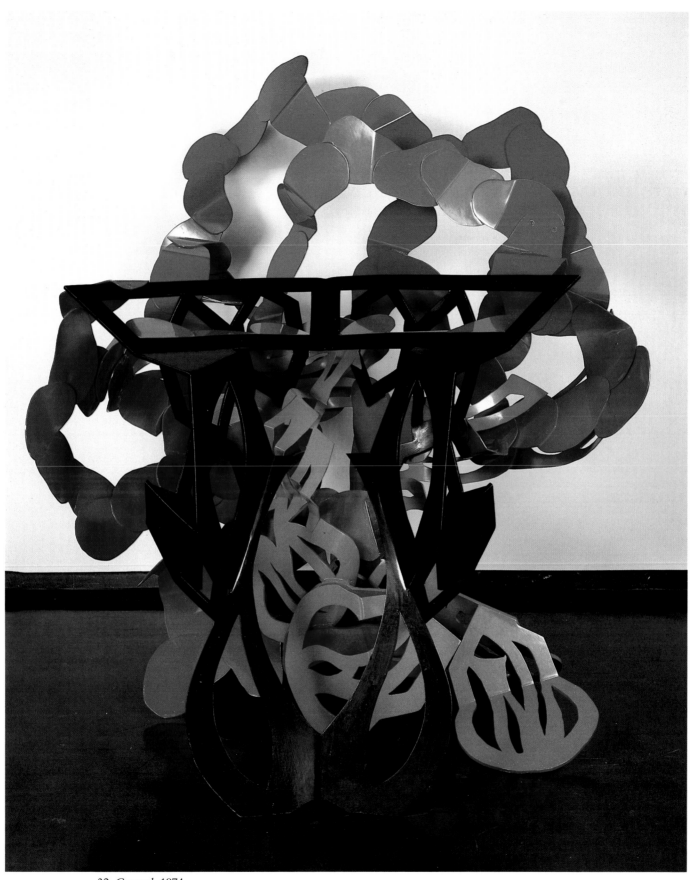

32. *Concord,* 1974

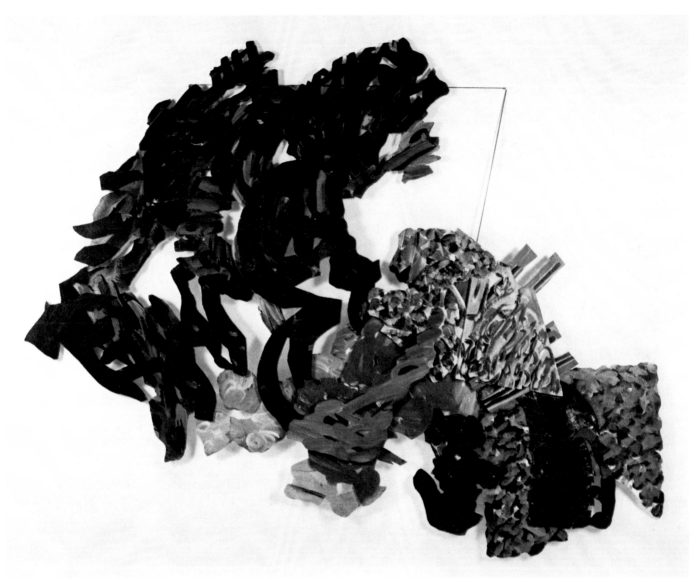

36. *Untitled*, 1977

by Irving Sandler

George Sugarman and Construction Sculpture in the Sixties

George Sugarman's artistic intentions are essentially formalist. As he summed it up: "Abstract art has had a long, autonomous existence, long enough for us to attempt to give it its own abstract content." He proposes to continue "the modern tradition of extending our inquiries into form and space, which also expands the conceptual language of art — opening possibilities, not closing them. The search must be for a language specific to sculpture, one not dependent on architecture, engineering, psychology, etc."[1] Sugarman is aware that his sculpture has always been affirmative, robust, dramatic, and poetic, often extravagant, but that is the result of his temperament; he has neither cultivated nor avoided these qualities. Early in his career, Sugarman decided that his formalist purpose was thwarted by attempts to create figurative images. Moreover, he came to believe that associations with nature detract from sculptural issues and values. Since 1954, he has been an abstract or, more accurately, nonobjective artist.

To put it another way, Sugarman considers his artistic enterprise as the posing of questions concerning form and color in space. Among the questions he has asked are, in his own words: "What would happen if: I put sculpture on the floor; I put it on the ceiling; I got rid of the pedestal or integrated it; I covered whole walls with sculpture; I separated the parts of a sculpture and made them diverse; I used color; I extended its relationships into space in all directions; I combined elements of painting and sculpture."[2]

During the late fifties, Sugarman began to laminate pieces of found wood and by carving, sawing, and power sanding, and further lamination built a prodigious variety of geometric and organic, open and closed shapes. He then joined these improvised, invented volumes to improvise constructions in space. By 1960, he started to set contrasting shapes side by side in what he called "extended space." To further separate and individuate the components of his sculpture, he painted each a different intense, solid acrylic color. For example, in *Bardana* (1962–63), a work which begins near the floor and steps up and out to a height of eight feet, there is a sequence of massive green and ocher organic shapes; a medley of red slats that opens like an accordion; and a heavy, angular, black scaffolding whose aggressiveness contrasts with the gracefulness of a labyrinth of curved, linear, white forms at the top.

As I observed, Sugarman is a formalist above all, but his sculpture is often experienced by viewers as emotional and as metaphor. He understands why his work is perceived as emotive, most likely because of its color, and he accepts it, although he does not set out to evoke specific feelings. On the issue of metaphor, he wrote: "All art is metaphor, if one wants it that way . . . [It can also be] sheer physical stimulation or the insistence on a system of formal relationships that has meaning in and for itself. Metaphor, stimulation, formal relationships, three ways to meaning. Is it necessary to choose? My choice has been not to eliminate but to keep all

1. George Sugarman, Statement, in "Sensibility of the Sixties," edited by Barbara Rose and Irving Sandler, *Art in America*, January-February 1967, p. 51.
2. George Sugarman, Statement, in Press Release for a show of his relief collages and models for public sculpture, Robert Miller Gallery, New York, 1980, n.p.

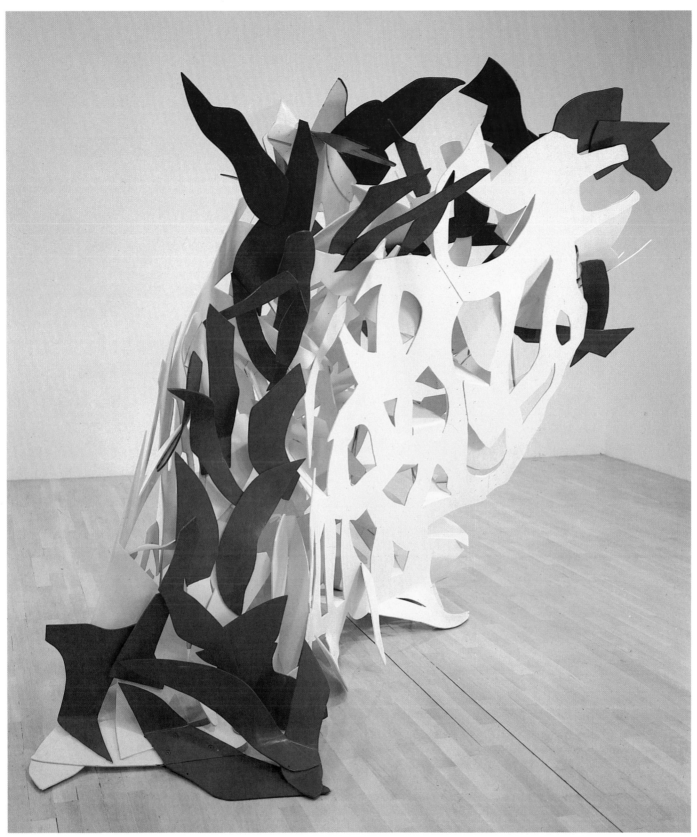

33. *One*, 1975–77

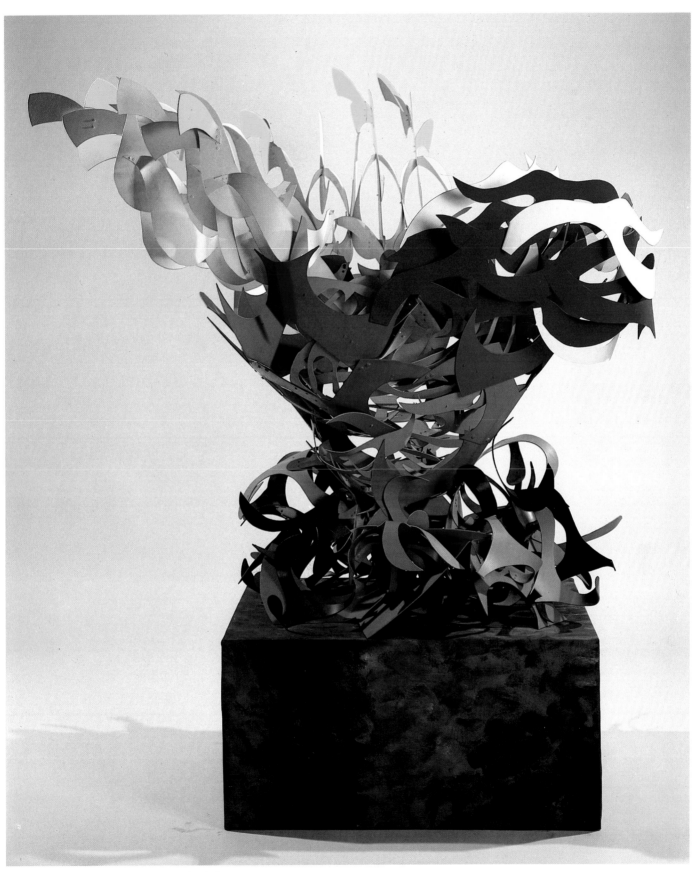

35. *Orange Around*, 1977

Bardana, 1962–63, polychromed wood, 96 x 144 x 62. Collection of Gallerie Renee Ziegler, Zurich, Switzerland.

possible sources of meaning open. *Open* is a word I like . . . *Complexity* is another."[3]

As metaphor, Sugarman's polyglot forms are often taken to evoke the variety and multiplicity of contemporary urban life. For example, the dissociation in his pieces calls to mind the incongruity of New York, in which it is common to find a Beaux-Arts building abutting an Art Deco apartment house or factory abutting a high-rise, glass curtain-walled or perhaps Gothic Revival office building. There is, moreover, in Manhattan, where Sugarman has lived and worked for a quarter of a century, the sharp contrast in scale between skyscrapers on the North-South avenues and brownstones on the East-West streets.

The emphasis in Sugarman's construction is on the individual component more than on the work as a whole; that is, the parts tend to be apprehended in sequence, one by one. Each of his sculptures seems to be made up of many sculptures. This fosters openness and complexity since there are no expected relationships among the disparate parts. But there is an allover unity. As Sugarman wrote, no form or color is allowed to become dominant; "a rigorous formal relationship throughout keeps each element

in its place while allowing it its maximum assertiveness."[4]

Sugarman's use of color is innovative; he was the first modern sculptor to apply a solid coat of paint to every one of his volumetric shapes in order to project color fully in three dimensions. His strung-out, continuous structure was also new in sculpture, as was that of his close friend, Al Held, in painting. Indeed, Sugarman and Held dared to experiment with this novel composition, seemingly and potentially open-ended, because both felt that the rhythmic arrangement of more or less similar forms around a central axis in sculpture or contained within the picture limits in painting had become too ordinary and outworn. To avoid the expected manner of composing — it came to be called "relational" in the sixties — they even imposed "rules" on themselves, for example, never to repeat a form or color in the same work. Moreover, there was in relational design a visual ambiguity that made Sugarman and Held uncomfortable. They wanted — in fact, aspired to — clarity, that is, the articulation of each form in its own space as a specific, self-contained entity, and this at a time when the dominant style was amorphously "painterly" — both in painting and in sculpture. Sugarman and Held were friendly with other artists who had begun to value clear form and clear color in art, among them Ronald Bladen, Sylvia Stone, Tom Doyle, David Weinrib, Sal Romano, and Nicholas Krushenick, most of whom were members of the Brata Gallery, an artists' co-operative on Tenth Street in downtown New York.[5]

Because of his urge to disjoin the segments of his constructions, Sugarman had to invent a great variety of forms, and the abundance of his ideas, his imaginativeness, distinguished him from any sculptor of his generation. Facilitating his invention of forms was the technique of lamination, since it enabled him to improvise freely, although he generally had an intuitive idea to begin with which he tried to keep in touch with, to keep fresh, in the long process of working it into his sculpture. Because he

3. George Sugarman, Statement, in the catalogue of a show of his sculpture at the Virginia Zabriskie Gallery, New York, 1974, n.p.
4. Ibid. Another element which unifies Sugarman's sculpture is the uniform coat of paint.
5. In 1965, I organized a show titled "Concrete Expressionism" at New York University consisting of paintings and sculpture by Ronald Bladen, Al Held, Knox Martin, George Sugarman, and David Weinrib.

38. *Five Verticals*, 1978

37. *Boundaries*, 1978

42. *Festival*, 1980

insists on the primacy of his own invention, Sugarman shuns ready-made materials which focus attention on themselves as materials, for example, found objects which evoke their original functions, or industrial substances such as plastics which call attention to themselves as materials. One reason, although a secondary one, that Sugarman paints his pieces is to conceal the beauty of the wood he uses and also the skill of his workmanship.

Sugarman's forms tend to be bulky, because sculpture's uniqueness as an art is in its three-dimensionality, but they activate the space within and around themselves and, moreover, are so joined as to further charge space. This motile, spatial dimension is critical to him, because he believes that to be contemporary sculpture an object must create the space that penetrates and surrounds it and makes it visible. Sugarman once said: "My absolute conviction is that the purpose of a sculptor is to create the presence of space."[6] He also believes that "if a piece of sculpture feels like a *thing*, even a beautiful thing, it's a failure. He wants a more energetic relationship between the work and the space it creates, for the sake of vivid response."[7] Color also contributes to spatial animation, speeding or slowing the eye as it follows a progression of forms — the "go" of a red to orange as against the "stop" of an orange to blue.

Sugarman's antipathy toward sculpture-as-object in circumscribed space, which is exemplified at its most trivial by coffee table *objets d'art*, was one reason for his elimination of pedestals, because they set off and ensconce works as precious. Another reason was that pedestals are dead forms, anathema to an artist who values invention. However, in a few pieces, such as *Ritual Place* (1964–65), Sugarman

incorporated the base into the construction. His anti-object stance also prompted him to project his sculpture horizontally as early as 1959 in *Six Forms in Pine*, an unpainted piece, one of his last without color.[8] (This work won second prize at the prestigious Carnegie International Exhibition in 1961.[9]) *Six Forms* was completed before Anthony Caro made his horizontal welded metal constructions. Caro, who is more identified with floor-hugging sculpture than Sugarman, largely because he has worked more consistently in this vein, did not have his first show in New York until 1964. In that year, not having seen Caro's work, Sugarman made his most extreme floor piece, titled *Inscape*. This was a seminal construction for Sugarman, not only because it flowed in relation to the floor but because its sprawl into the environment of the gallery pointed the way to the monumental sculpture for public places that was to occupy Sugarman increasingly after 1966, and this despite the fact that *Inscape* was a closed oval and low in height, causing the spectator to stay outside and tower over it.

As I remarked, Sugarman introduced color to aid him in dissociating his forms. This use of color issued from a formal *need*, from his novel conception of structure; his color was necessary and integral, not arbitrarily added, and thus not decorative or cosmetic. The forms were arrived at first and suggested their colors; the specific tones were decided upon in the process of laminating and carving, sawing, and sanding, because they served to articulate the volumes in space. This use of color provided Sugarman with a difficult challenge, since the coat of color on a three-dimensional shape is both a skin and optical in the sense that color is disembodied, appeal-

6. Paula Harper, "George Sugarman: The Fullness of Time," *Arts Magazine*, September 1980, p. 158.
7. Amy Goldin, "The Sculpture of George Sugarman," *Arts Magazine*, June 1966, p. 28.
8. Sugarman had actually made horizontal pieces while he was in Paris in the early fifties. One such piece was exhibited in New York, in a three-man show at the Brata Gallery in 1958.
9. Alberto Giacometti won the first prize at the Carnegie International Exhibition in 1961, and David Smith the third. The unexpected prize for Sugarman was a mixed blessing. It catapulted him to international fame but, because he was an unknown artist, his elevation over Smith, considered widely in the New York art world as America's (and probably the world's) greatest sculptor, was looked upon as unseemly, and this was held against Sugarman. What exacerbated his position was the confusion created by his exhibition which opened two days after his winning the prize — an exhibition not of unpainted pieces like the Carnegie prize winner, but of polychromed sculptures which, because they were unexpectedly painted, were doubly controversial.

39. *Detroit Commission*, 1979, polychromed aluminum model, seven parts. Joint Art Commission, New Detroit Receiving Hospital and University Health Center, Wayne State University.

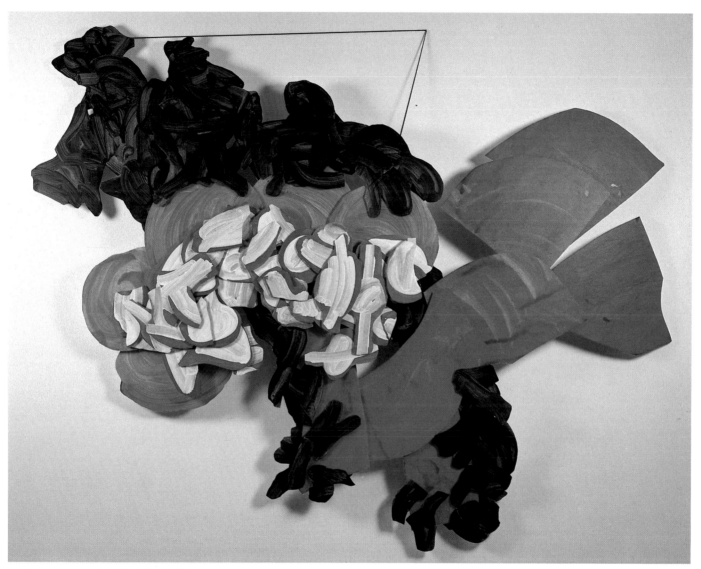

43. *Big Ride*, 1981

ing primarily to the sense of sight as distinct from the sense of touch. As such, color tends to act against the tactile solid that it thinly coats. During the early sixties, only a few sculptors, for example, John Chamberlain, dared to use a palette as high-keyed as that of Sugarman. But Sugarman alone succeeded in using color as weight to define and augment mass.

From the first, Sugarman's color has been the most controversial element in his work, and not because the hues are generally strong and their interactions startling. In fact, his colors are more often than not perceived as pleasing, even ingratiating. But color's place in sculpture has been problematic since it was banned in "high" sculpture during the Renaissance. In the sixties, it was called into question by such important writers as Clement Greenberg and Robert Morris; Greenberg, with respect to David Smith's work, called it vexing,[10] and Morris termed it "inconsistent with . . . obdurate, literal mass."[11] Since then, color has become an accepted element in sculpture and one which has enriched it immeasurably, and much of the credit is due to Sugarman.

★ ★ ★

Sugarman's juxtaposition of unrelated volumes in extended space challenged the dominant manner of composing in abstract sculpture of the time, the "Cubist" structuring, as he called it, of such metal welders as Ibram Lassaw, Herbert Ferber, David Hare, Theodore Roszak, and Seymour Lipton, as well as David Smith and the younger artists influenced by him, the most masterful of whom were Mark di Suvero and Anthony Caro. With regard to the younger metal workers generally, Sugarman asked rhetorically: "Must we remain the obedient children of our ancient fathers? Isn't it about time we went for a stroll of our own in 1959?"[12] Later, Sugarman's aesthetic would oppose that of the Minimalists, such as Donald Judd, Robert Morris, Carl Andre, and Sol LeWitt, even though they, like him, were anti-Cubist. The unfolding of abstract sculpture during the sixties can be viewed as part of a three-cornered debate about what art is and ought to be. This conflict of ideas was valuable because it generated self-criticism, compelling artists to justify what they were making, and in the end, toughening their conviction of the validity of their individual visions.

As Sugarman saw it, the unifying principle of Cubist design is the composition of forms related in shape and tone to an explicit or implicit central axis. This axis is generally vertical, calling to mind the upright human figure. Sugarman felt restricted by the confinement of both balanced Cubist structure and its figurative references. Above all, he rejected the ambiguity of its relational or part-to-whole organization, particularly when the elements are profuse and linear — a kind of intricate drawing in space — and their surfaces textured, as if the oxyacetyline torch was used like a brush. The resulting bubbled and fretted metal skin resembled the brushy facture of Abstract Expressionism. However, much as he rejected the confinement of Cubist design and the "painterly" handling of surfaces, Sugarman was attracted by the way in which Cubist-related welded construction opens and energizes space and by its improvisational approach; his own technique might be called welding-in-wood.

Of the metal sculptors whose work exerted pressure on the art of the sixties, Sugarman found Smith and di Suvero to his liking, because their forms were more massive and clearer than those of their contemporaries. He was stimulated by Smith's less figural, less linear and planar, more volumetric pieces, such as *Cubi XVII* and others in this series, and di Suvero's muscular constructions with multiple focal points, which stretched Cubist, centripetal composition to its outer limits. Actually, Sugarman was interested more in Richard Stankiewicz's junk constructions, because of their imaginativeness, and Alexander Calder's stabiles, in which disparate complexes, sometimes of different colors, are placed side by side, and also the mobiles, because of their ordered yet open-ended or endless movement. It is a sign of Sugarman's independence of mind that he

10. Sidney Geist, "Color It Sculpture." *Arts Yearbook* 8, 1965, p. 98.
11. Robert Morris, "Notes on Sculpture: Part 1," *Artforum*, February 1966, p. 43.
12. George Sugarman, Statement, in "Is There a New Academy? Part 2," edited by Irving Sandler, *Art News*, September 1959, p. 60.

should have looked to Calder at a time when he was not taken very seriously by the New York School.

Caro's constructions of the sixties have certain relationships to Sugarman's in that they are nonobjective and oriented to the floor, like *Inscape*. However, far outweighing the similarities are the differences, such as Caro's preference for pre-existing, manufactured, right-angled, standard structural form, for example, I-beams, and the sense of dematerialization, pictorial as much as it is sculptural, that his pieces convey. What made Caro's work different from Sugarman's is evident in a remark by Clement Greenberg: "Rarely does a single shape in Caro's sculpture give satisfaction by itself. . . Michael Fried speaks aptly of Caro's 'achieved weightlessness' which has sprung from Cubist collage. Part of Caro's originality of style consists in denying weight . . . Applied color is another means to weightlessness in Caro's art, as Michael Fried, again, points out. It acts . . . to deprive metal surfaces of their tactile connotations and render them more 'optical'."[13] In contrast, Sugarman uses color to make his forms appear more weighty. It is noteworthy that Caro generally painted each of his pieces a single, allover color, whereas Sugarman painted each part of his work a different color, so that in itself, as a separable entity, each part is visually stimulating.

Poles apart from Sugarman's and Caro's sculptures are Minimalist works or, as they have been called by Donald Judd, "specific objects," and by Robert Morris, "unitary forms" — sculpture which began to take the limelight in the New York art world around 1965. Judd and Morris, among others, built (or had built for them) works composed of single geometric volumes or of identical geometric units, like modules, in symmetrical arrangements, for example, checkerboard grids, whose patterns are immediately apparent. Although there were significant differences in the approaches of Minimalist sculptors, their aim generally was to purify sculpture, subtracting any reference to image, painting, architecture, etc., that is, to simplify it to its irreducible nature or essence — as an aesthetic object, on the one hand, making it more like a literal

thing, massive, indivisible and stable, seen all at once and not part by part, and on the other hand, as more aesthetic, isolating and revealing exclusively and impassively the autonomous sculptureness of sculpture. On the whole, this is the Minimalist justification for paring away everything that is not of the medium, primarily all signs of life. In keeping with their intended "anti-anthropomorphism," their avoidance of any reference to the human body and its movements, these artists naturally limited themselves to simple, uninflected, generally monochromatic, uniform, geometric shapes.

However, like Sugarman, Judd and Morris developed their works in reaction against welded metal construction, and like his, their forms are often monolithic, but there all similarity ends. The bareness of unitary objects, their neutrality and austerity in shape, color, and surface, directs attention to the irreducible limits of sculpture, to qualities which have been renounced. In contrast, Sugarman's seemingly unbalanced forms, varied in shape and color, which activate space, call to mind the abundance, surprise, and open-endedness of his formal invention, to his rich use of the language of sculpture. Whereas Minimalist objects can be instantly visualized, since parts are eliminated to emphasize the whole, Sugarman's constructions take time to be seen, not only because all of the parts are different but because they are strung out and the whole is not immediately visible. In summary, unlike Minimalist works which are self-contained and inert, passive and impassive, Sugarman's sculptures are dynamic, energizing rather than occupying space, complex, muscular, sensuous, and exuberant. Because of his love of energy, Sugarman prefers idiosyncratic Minimalists, such as Tony Smith and, even more, Ronald Bladen, whose geometric volumes thrust off-axis heroically or are precariously balanced.

Two in One (1966), a floor piece like *Inscape*, was the largest and most complex piece that Sugarman had made up to that time. It was his challenge to purist, see-it-all-at-once, single image, Minimalist art. Its twenty-eight segments extend across the floor in a V configuration, all disparate even though

13. Clement Greenberg, Introduction, *Anthony Caro*, exhibition catalogue, Rijksmuseum-Kroller-Muller, Otterlo, Holland, 1967, n.p. This essay was written in 1965.

one extension is composed mainly of geometric shapes and the other extension of organic ones. The work is so huge that it can only be experienced by walking along, around, and in it. From one side, the other side can be seen through openings across an open space, in glimpses, as it were. This screening of an interior volume was new, and Sugarman would return to it in subsequent works.

<p style="text-align:center">★ ★ ★</p>

By 1965, Sugarman had achieved a clear sense of his artistic identity, so much so that he felt free to relax the "rules" he imposed on himself, for example, not to repeat a form or a color in a single work, and even to break them. In *C-Change* (1965), he turned from discontinuity to continuity and change. Using a C form as his theme, Sugarman permutated it in sequence, like an abstract narrative, from organic to geometric, from volumetric to linear, from closed to open. *Yellow to White to Blue to Black* (1967) is what Sugarman called a "field sculpture." In this work, he situated three volumes in space at a distance from each other, each segment calling to mind a separate piece. However, the elements are closely related; all investigate interior spaces; their motifs ricochet from section to section back and forth across space. But they are dissociated by the spectator's inability to see the whole from any position at any one time.

In *Ten* (1968–69), Sugarman completely abandoned dissociation and extended space and instead focused on the interior volume which, like that of a shell, is enveloped by a thin outer form. This all-white sculpture is composed of ten separate vertical parts arranged in an oval into whose shadowed — and enigmatic — inner space the viewer can glimpse but not enter. In *Trio* (1969), Sugarman opened up the "shell," delineating an interior volume with a yellow linear configuration based on the oval; the emphasis here is on openness and lightness.

In 1970, *Yellow to White to Blue to Black* was enlarged to twice its size, fabricated in steel, and installed in a plaza in front of the Xerox building in El Segundo, California. This "field sculpture" became Sugarman's first monumental work in a public space, the first of many which would occupy him for a decade. In keeping with his new interest in public art, Sugarman turned from laminating and

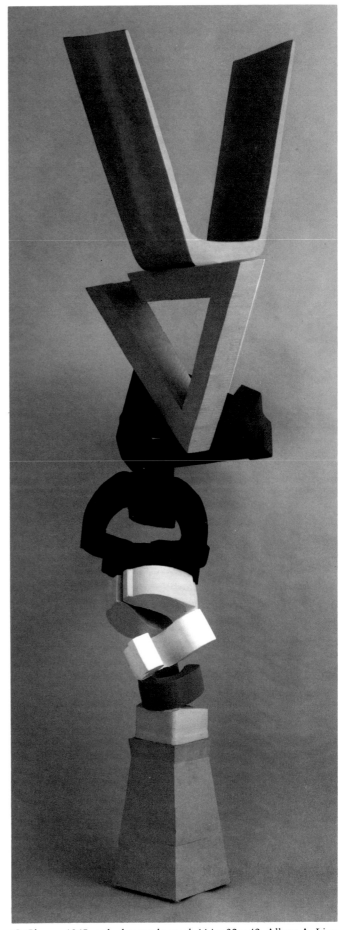

C-Change, 1965, polychromed wood, 114 x 32 x 42. Albert A. List Family Collection. Photo: John A. Ferrari.

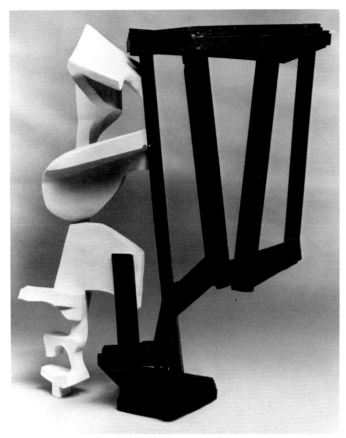

Blue, Black, and White, 1961, polychromed wood, 97 x 61 x 61. Collection of Kunsthaus Zurich, Switzerland.

carving wood to composing models in cardboard and having them fabricated in metal under his supervision. Metal lent itself to large scale, outdoor sculpture as wood did not. But dealing with that development would require another essay, as would his ventures into painting and painted relief-collages. Suffice it to say that no matter what changes took place in his work, Sugarman's adventurousness and imagination have never faltered.

Because of its complexity and inventiveness, Sugarman's sculpture was eclipsed by Minimalist styles in the sixties. But he anticipated the sensibility of the seventies and came into his own in that decade, hailed as a forerunner by a younger generation who reacted against the austerities of their elders and responded positively to the visual richness of his art. His influence shows in the frequent use of color and diverse forms, the mixing of painting and sculpture, and the development of the concept of field sculpture. The relevance of Sugarman's work to young artists has changed the public response to it. It has now found a far more open and sympathetic audience than it ever had in the past.

40. *Sanctuary*, 1979

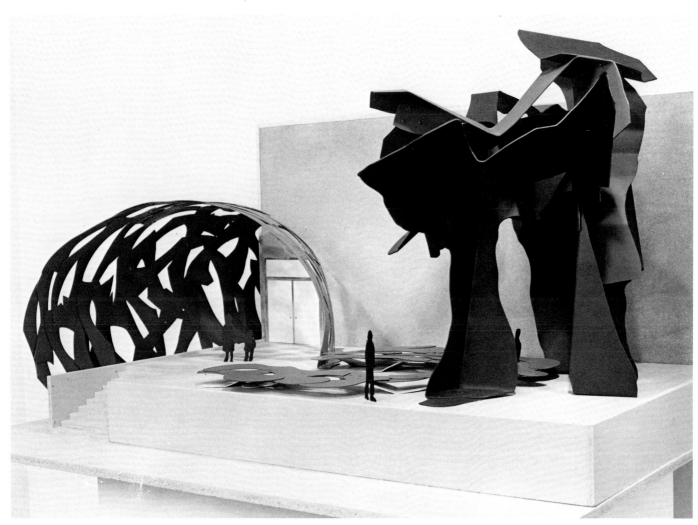

41. *Study for Sculpture in Relation to Architecture*, 1979

by Brad Davis

Recollections

I first met George on a visit to New York in 1967, I think. We hit it off right away. His assistant had gotten sick the week before. I decided to stay in New York and I went to work for him the next week.

★　　★　　★

He "tested me out" sanding a small "calligraphic" piece that still hangs on his living room wall. His first instruction was, "Don't finish it too well." He didn't want it slick, just the forms clear. Later he said, "I don't care about the wood, just the form."

★　　★　　★

My past carpentry didn't prepare me for what we did in the studio. There was a lot of improvisation of techniques. George was the first to admit he was no draftsman, but somehow he was able to convey to us how he wanted it built and it usually worked.

★　　★　　★

The day would start with a "conference." He would have looked at the work and thought about it the night before. In the morning a discussion would develop and out of it the solutions to the day's work. George "played off" his assistants to develop his thinking and it often amazed me how he would come up with solutions through this "give and take." It also helped to make me feel part of the piece and more involved with the underlying ideas than just a workman. It was a great learning experience for me — sharpening both my eye and formal vocabulary.

★　　★　　★

The building process was slow. I cut shapes from two-inch sugar pine on a band saw, laminated them with glue, screws, and dowels, and shaped the form with heavy disc and belt sanders. Often only a layer or two was added each day. As the form took shape it wasn't uncommon to run into the screws or dowels. They then had to be filled or replaced. Also, forms sometimes would be sanded too far and have to be built up again with putty. The sugar pine was very soft and easily sanded, but it needed reinforcement; so it was a constant battle between freedom of the form and what would hold. In most cases the form won out while the materials were stretched to their limits.

★　　★　　★

The yellow form of *From Yellow to White to Blue to Black* was my introduction to how George built a form. He gave me a cardboard template of the vertical face. Then he described how he thought the form should develop from this outline. I couldn't visualize it at first, but he never made a drawing of it, probably because he wasn't entirely sure how it would come out. Layer on layer, it developed like a sea shell. He talked me through the whole process without ever showing me and somehow I got it. After that I never had any trouble.

★　　★　　★

Not only was the yellow piece my test piece, it just wouldn't stand up. It tipped to one side because the foot was too narrow for such a long cantilever. We talked about it for a few days and finally ended up drilling and pouring lead counter weights. This little trick saved many of George's more precarious pieces from gravity.

★　　★　　★

As the pieces became more technically ambitious and the building slower, George took on more assistants to keep up with exhibition demands. Jed Bark, then a sculpture graduate student at Hunter; Jody Wells, a young painter from New England; Todd

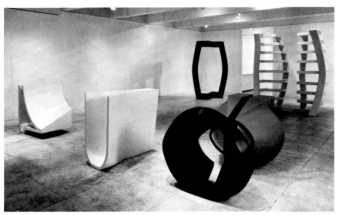

Installation at Fischbach Gallery, 1968, with (from left to right) *From Yellow to White to Blue to Black* and *Two Fold*.

Nardin, a recent high school graduate and musician; and finally Peter Capurso, a painting student from the School of Visual Arts. The studio roared continuously with three or four power tools and was blanketed in a thick fog of sawdust. All the while George worked in the front studio on drawings and color ideas for the pieces, occasionally dropping in to see the progress and discuss changes. It seemed he needed to distance himself from the making to concentrate on their ideas. The pieces became much clearer in form and sophisticated in relationship to each other.

★ ★ ★

George always seemed to start with an idea. They came from many sources. A picture in a book, a fragment in the studio, a piece of music, a book from his wide reading, or just thinking about sculpture. But each piece was anchored in an idea about sculptural form. There were several large ongoing themes he would discuss: the growth in shell forms from origin to end; the relationship and interdependence of separated forms, a sort of separate but equal; or a sculptural expression of the musical theme and variation. But foremost was the creation of space, whether single forms trapping and articulating interior space or groups creating and defining open space. For George space defined modern sculpture.

★ ★ ★

Color was of great interest to George. It's safe to say he was proud of his contribution to the use of color as well as getting sculpture off the base and on the floor. He had very clear ideas about color amplifying and clarifying a form, and regarded most recent use of color as merely cosmetic. But he was never rigid in his use of color. He often tried our choices if the rational approach didn't provide a solution and could be quite lyrical and exuberant with the color. However, it was never frivolous. For all the pizzazz there always seemed an underlying reason.

★ ★ ★

It's misleading to stress George's rational approach. Sometimes after long discussion of a piece's formal qualities, I would protest it's more than that. George would say, "Yes, but I don't think about that. It's just there." He would admit that notions of beauty, humor, psychology, even theatricality (theatre was George's first love) were always in his mind. They filled out an idea and gave it humanity, he thought. This underlying assumption of the natural fullness of art prevented his work from being didactic in a time it was so prevalent.

★ ★ ★

George's style is always hard to pin down. I finally caught a glimpse of it photographing *Ten*. It was the last large piece I built for George and seemed very different in its steamlined elegance from earlier pieces. It was never possible to see it from a distance or from the side the way we built it in the studio. But the afternoon we photographed it we turned it sideways and, as I stepped back, I burst into laughter. For all its purity of form, in profile it had a funky awkwardness only George could have conceived.

★ ★ ★

Ten was a great favorite of mine. It was a real challenge to build exact symmetry and its refinement. But it also had a mystery to me somewhere between an Egyptian sarcophagus and a tantric cosmic egg. Its meaning was very elusive. I said this to Amy Goldin once and she replied, "Oh, I think it's George's idea of the perfect woman."

★ ★ ★

Amy Goldin once told me that while she was a reviewer for *Art News* she went to one of George's shows at Stephen Radisch. "I fell in love with that piece with the blue blob on top. It was like Ionesco. Anybody who could do something that crazy, I want to meet."

★ ★ ★

George paid and treated his assistants well, and in return he got real devotion and quality work. He often said he was a lousy craftsman and appreciated the work we did. But there was more. George in-

vited us into his thinking. He discussed things very openly and threw around ideas often beyond the scope of the work — that was exciting and a great pleasure. Lunch and tea were always important times of the day. George loved to discuss art, ideas, or the latest shows, and discussions often continued over several days. He is a talker and provocateur, and we loved to take him on. It was a rare and stimulating way to learn, sharpen your wits, and toughen your hide. It beat any graduate school and functioned much like I imagine the old apprenticeship system.

★　　★　　★

Also there was great pleasure in working on the pieces themselves. It is hard to convey the pleasure of sanding a joint inside one of the big shell forms or the craziness of repainting a hundred little paintings on *Axum*.

★　　★　　★

I remember his leaving for a show in Europe and giving me instructions to rebuild a damaged piece. When he returned several weeks later, it was exactly as he would have done it and I knew the apprenticeship was over. I had imbibed his work, now I had to go off and do my own.

★　　★　　★

I think George was very hurt by the opposition to the Baltimore piece. It was his most "social" work, a piece that draws people to it, shelters them, and to have it become a "social" problem spoiled its idealism. It was really the chief Judge against George. But George fought for his beliefs and, although it exhausted him, he was gratified by the support he got in the end.

★　　★　　★

I remember thinking those conservative Minnesota bankers would never accept the St. Paul piece that literally explodes out of the corner of the building. But George has the rare ability to "infect" his audience with the joy and exuberance of his work and at the same time, make its intelligence clear to them.

★　　★　　★

George was always interested in young artists. He supported the early happenings, Judson dance and much of the new music. While he takes current exhibitions seriously, he can be a very harsh critic of young artists, often faulting an emerging idea as if it were from someone as mature as he. Sometimes I

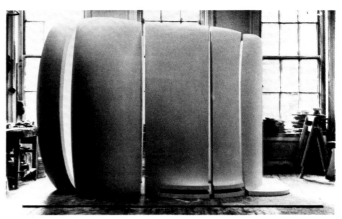

Ten in Sugarman's studio, 1969.

think he is vying for chief curmudgeon of the art world.

★　　★　　★

George's interest in music goes back to his childhood. He came from a musical family. He still is a concert-goer and has a large collection of records. When I first met him he was listening to Handel, Haydn, and Mozart and especially interested in Pierre Boulez's writings on structural ideas in music. Music had a great influence on his sculptural ideas.

★　　★　　★

George has friends and outside interests, but none as strong as his work. I think of him as an "art monk," devoting virtually all his energy toward his art. It is the art of both the inner and outer man. It is as wide and rich as the experience of a whole person.

★　　★　　★

During the early seventies, a period of many of George's large commissions, he started painting, first as an outlet between the delays and deferments of a finished product, then as a way to "push" new ideas. Pattern painting was emerging and from his long experience with repetition in his sculpture, George felt he could do it better. Also a new and spooky psychological imagery evolved that is strongly reminiscent of current "new wave" painting. These works are the precursors of the relief paintings he has shown in the past few years. Although these paintings have never been shown, I think because George questions their level of accomplishment, they are incredibly rich, complex, and revealing as examples of George's inner researches.

★　　★　　★

Not only does he delve into himself for inspiration, George draws on the past history of art, again similar to current tendencies. He has a big library of art and picture books and freely draws on Oriental, Near Eastern, as well as older European art, although it could be the *New York Times* sports page or a tropical bird book.

★ ★ ★

Of all artists, George spoke most highly of Picasso. He felt Picasso's ideas gave birth to twentieth century sculpture. Although he did not develop them, Picasso, with Gonzalez, originated the notion of open, space defining, abstract sculpture. George felt he was building on this Cubist tradition. Although he often said, "I don't mean Cubist style. Cubism means freedom to me." Freedom from the figure and mass, as well as freedom to invent.

★ ★ ★

Oldenburg was the contemporary sculptor he spoke of most favorably. He liked his wit and invention and his use of new materials to get new forms. While he chose abstract forms in his own work, he never had problems with subject matter. He could speak favorably of Anne Arnold's dogs as well as Don Judd's boxes.

★ ★ ★

George was generally responsive to new ideas in sculpture. I remember him liking Alan Saret's open wire pieces when he first saw them. The idea of open extendable sculptures was one of George's interests, too. But he was disappointed when it became a stylistic device in Saret's work.

★ ★ ★

Style was something George tried hard to avoid in his own work and criticized it strongly in others. He felt style was okay if it occurred naturally as a result of the artist's hand or personality, but it was never a pursuit in itself. George has always talked of "pushing" his work so it never becomes a style for him.

Some criticize his work for its endless change and pursuit of new forms and means. For me it is one of his strengths and signs of integrity of purpose.

★ ★ ★

George has always responded to the major ideas of the time. His early work has the gesture, rawness, and emotion of Abstract Expressionism sculpture. He responded to the clarity of form and the gestalt of groupings important to Minimalism, and his use of complex color and repetition relates strongly to the newer Pattern and Decoration. In each case George was a forerunner in the use of these ideas. He developed a very personal and distinctive use of them. As a consequence he was never really identified with the movements as such, and often overlooked when they were discussed. Still, George remains one of the great individualists.

★ ★ ★

George's father was an Oriental rug salesman for a time, and he has said that he can still remember some of the designs, so beautiful and vivid were they to him as a child. He has also said that a bad Mannerist painting is still more interesting to him than a good Persian rug because the intuitions about art go deeper for him.

★ ★ ★

When George was in Europe on the G.I. Bill, he went to Zadkine's class in Paris. He told me he was there a week when he realized that was worthless and began to work on his own and travel. He said that the architectural details he sketched in his travels had the greatest impact on his sculpture later in New York.

★ ★ ★

I think for a group of young artists, George is an example of true individualism in an art world of marketing "isms," and integrity in the winds of constant change.

★ ★ ★

Artist Brad Davis was George Sugarman's assistant from 1967 to 1969.

All measurements in inches, height precedes width precedes depth.
**For exhibition at Joslyn Art Museum only.*

Catalogue of Sculpture

THE FIFTIES

1. *Untitled Three Abstract Figures,* 1952–53
 carved elm, 18 x 48 x 18 (approximately)
 Collection of the artist

2. *Memories of Mortality,* 1953
 terra cotta, 18 x 30 x 10 (approximately)
 Collection of the artist

3. *Untitled Terra Cotta Group,* 1953
 terra cotta, 24 x 36 x 12
 Collection of the artist

4. *Many Harbors, Many Reefs,* 1955–56
 laminated oak, 18 x 7 x 8
 Collection of the artist

5. *Improvisation on the Winds,* 1956
 oak, 22 x 27 x 14
 Permanent Collection, Massachusetts Institute
 of Technology, Cambridge

6. *West of the Mississippi,* 1956–57
 wall relief, laminated pine, 23 x 49 x 3
 Collection of the artist

7. *Memorial to Walt Whitman,* 1957
 laminated maple, 17 x 12 x 11
 Collection of Jane Suydam

8. *Percussion,* 1957
 laminated poplar, 21 x 19 x 22
 The George Peabody Collection of
 Vanderbilt University, Nashville, Gift of the artist

9. *The Sunken Vessel,* 1957
 laminated pine, 14 x 7 x 5
 Collection of the artist

10. *Six Forms in Pine,* 1959
 laminated pine, 59 x 143 x 59
 Collection of the artist

11. *The Wall,* 1959
 laminated pear wood, 22 x 35 x 6
 Collection of the artist

THE SIXTIES

12. *Yellow Top,* 1960★
 polychromed laminated wood, 87 x 54 x 34
 Walker Art Center, Minneapolis,
 Gift of the T. B. Walker Foundation

13. *One for Ornette Coleman,* 1961
 polychromed wood, 60 x 30 x 24
 Courtesy Robert Miller Gallery, New York

14. *Green and White,* 1962
 polychromed wood, 39 x 30 x 24
 Courtesy Robert Miller Gallery, New York

15. *Axum,* 1963★
 polychromed wood, 35 x 38 x 49
 Helen F. Spencer Museum of Art, The University
 of Kansas, Lawrence, Gift of the National Endowment
 for the Arts and the Friends of the Art Museum

16. *Criss-Cross,* 1963
 polychromed wood, 41 x 34 x 37
 Whitney Museum of American Art, New York,
 Lawrence H. Bloedel Bequest, 1977

17. *Fugue,* 1963
 polychromed wood, 64 x 43 x 54
 Museum of Fine Arts, Springfield, Massachusetts,
 Museum Purchase with the Aid of the National
 Endowment for the Arts

18. *Ramdam,* 1963
 polychromed wood, 122 x 48 x 48 (approximately)
 Mary and Leigh Block Gallery, Northwestern
 University, Evanston, Illinois, Gift of the Estate of
 the late Robert B. Mayer and Mrs. Robert B. Mayer

19. *Black and a Garland,* 1964
 polychromed wood, 40 x 25 x 21
 Collection of Mrs. Robert M. Benjamin

20. *Inscape,* 1964
polychromed wood, nine parts,
28 x 158 x 97 installed
Courtesy Robert Miller Gallery, New York

21. *The Shape of Change,* 1964
polychromed wood, 61 x 49 x 23
The Art Institute of Chicago,
Gift of Arnold Maremont

22. *Rorik,* 1965
polychromed wood, 32 x 26 x 15
Collection of Mr. and Mrs. David Michael Winton

23. *Two in One,* 1966
polychromed wood, nineteen parts,
85 x 286 x 134 installed
Collection of the artist

24. *Untitled Wall Relief,* 1966–69
polychromed wood, 36 x 66 x 11
Courtesy Robert Miller Gallery, New York

25. *Yellow to White to Blue to Black,* 1967
polychromed wood, five parts,
42 x 158 x 97 installed
Collection of the artist

26. *Untitled Wall Relief,* 1968
black laminated cardboard,
32 x 52 x 12
Collection of the artist

27. *Ten,* 1968–69★
polychromed wood, ten parts,
91 x 149 x 71 installed
The Museum of Modern Art, New York,
Harold and Hester Diamond and Mrs. Joseph James
Akston Funds, 1976

28. *Trio,* 1969–70
painted wood, two parts,
32 x 25 x 60 installed
Courtesy Robert Miller Gallery, New York

THE SEVENTIES

29. *Green and White Spiral,* 1970
polychromed wood, 33 x 33 x 46
Courtesy Robert Miller Gallery, New York

30. *Leverkusen Commission,* 1970
painted metal model, 36 x 50 x 58
Collection of the artist

31. *Blue Circle,* 1974
polychromed aluminum, 35 x 38 x 36
Courtesy Robert Miller Gallery, New York

32. *Concord,* 1974
polychromed aluminum, 96 x 90 x 60
Collection of the artist

33. *One,* 1975–77
polychromed aluminum, 84 x 72 x 78
Courtesy Robert Miller Gallery, New York

34. *First Light,* 1977
relief collage, acrylic on paper
mounted on foamcore board with
fiberglass, 58 x 88
Courtesy Robert Miller Gallery, New York

35. *Orange Around,* 1977
polychromed aluminum, 54 x 60 x 48
Courtesy Robert Miller Gallery, New York

36. *Untitled,* 1977
relief collage, acrylic on paper
mounted on foamcore board with
fiberglass, 66 x 84
Collection of the artist

37. *Boundaries,* 1978
polychromed aluminum, four parts,
19 x 100 x 95 installed
Courtesy Robert Miller Gallery, New York

38. *Five Verticals,* 1978
polychromed aluminum, 36 x 66 x 44
Collection of the artist

39. *Detroit Commission,* 1979
polychromed aluminum model, seven parts,
Joint Art Commission, New Detroit Receiving
Hospital and University Health Center,
Wayne State University

40. *Sanctuary,* 1979
relief collage, acrylic on paper
mounted on foamcore board with
fiberglass, 61 x 85
Collection of the artist

41. *Study for Sculpture in Relation
to Architecture,* 1979
polychromed aluminum and wood,
32 x 60 x 48
Collection of the artist

THE EIGHTIES

42. *Festival,* 1980
multipart relief collage, acrylic on paper
mounted on foamcore board with fiberglass,
108 x 360
Galerie Rudolf Zwirner, Cologne, West Germany

43. *Big Ride,* 1981
relief collage, acrylic on paper
mounted on foamcore board with
fiberglass, 68 x 47
Courtesy Robert Miller Gallery, New York

Catalogue of Cardboard Sketches

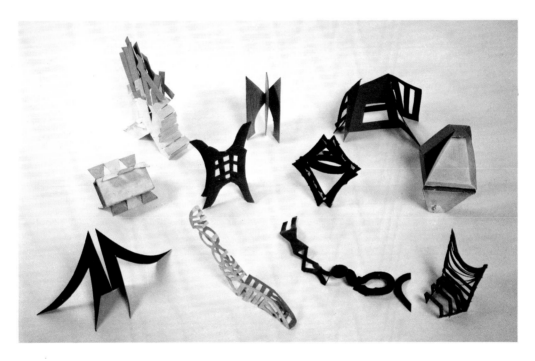

Untitled Cardboard Sketch No. 1
cardboard
Collection of the artist

Untitled Cardboard Sketch No. 2
cardboard
Collection of the artist

Untitled Cardboard Sketch No. 3
cardboard
Collection of the artist

Untitled Cardboard Sketch No. 4
cardboard
Collection of the artist

Untitled Cardboard Sketch No. 5
cardboard
Collection of the artist

Untitled Cardboard Sketch No. 6
cardboard
Collection of the artist

Untitled Cardboard Sketch No. 7
cardboard
Collection of the artist

Untitled Cardboard Sketch No. 8
cardboard
Collection of the artist

Untitled Cardboard Sketch No. 9
cardboard
Collection of the artist

Untitled Cardboard Sketch No. 10
cardboard
Collection of the artist

Untitled Cardboard Sketch No. 11
cardboard
Collection of the artist

All sketches made during the 1970s.

Drawing is, in some ways, one of the useful arts . . . A drawing, when it's useful, is for thinking. As a thinking tool, its value may be limited to the artist who makes it . . . To be in touch with an artist's thinking is the essential communication.

. . . These are drawing drawings. They stand alone, outside of any problem-solving, and the solutions they find belong to themselves. This is the nature of drawing, isn't it? Lightness, quickness, spontaneity, their wit and fragility carry enough energy to sustain themselves and the more ambitious works they generate.

George Sugarman, 1971[1]

1. Statement in connection with drawings exhibition at Gallery 118, Minneapolis, Minnesota, 1971.

Catalogue of Drawings

1. *Untitled,* 1950
ink on paper, 4¾ x 6⅞

2. *A Guided Tour of
Luxembourg,* 1950, ink on
paper, 6½ x 10¾

3. *Untitled,* 1950
ink on paper, 6⅞ x 4¾

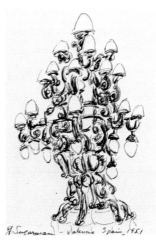

4. *Valencia, Spain 1951,* 1951
ink on paper, 7 x 5

5. *Untitled,* 1952
watercolor and ink on paper,
15 x 19¼

6. *Untitled,* 1952
ink on paper, 26 x 19⅝

7. *Untitled,* 1953
ink on paper, 19½ x 26

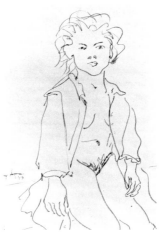

8. *Untitled,* 1953
ink on paper, 19⅛ x 14¼

9. *Untitled,* 1954
ink on paper, 17⅝ x 22⅛

10. *Untitled,* 1954
ink on paper, 17⅛ x 21½

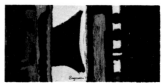

12. *Untitled,* 1954
ink and pastel on paper,
9 x 18½

11. *Untitled,* 1954
ink and pastel on paper,
27½ x 12¾

13. *Untitled,* 1956
ink on paper, 19⅞ x 26

14. *Untitled,* 1956
ink and pastel on paper,
19⅝ x 26⅛

15. *Untitled,* 1957
ink on paper, 21¼ x 30⅛

16. *Untitled,* 1957
ink on paper, 15⅞ x 19½

17. *Untitled,* 1957
ink on paper, 16 x 22½

18. *Untitled,* 1957
ink on paper, 12 x 9

19. *Untitled,* 1957
ink on paper, 21⅛ x 30⅛

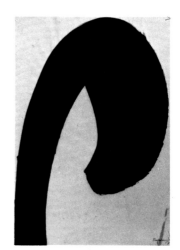

20. *Untitled,* 1957
ink on paper, 21 x 15

21. *Untitled,* 1957
ink on paper, 16 x 13½

22. *Untitled,* 1957
ink on paper, 16 x 22½

23. *Untitled,* 1957
ink on paper, 9 x 12

24. *Untitled,* 1957
ink on paper, 12 x 9

25. *Untitled,* 1957
ink and pastel on paper,
17¼ x 24⅞

26. *Untitled,* 1959
tempera on paper, 24⅛ x 18

27. *Untitled,* 8/1959
graphite and acrylic on paper,
35 x 23

28. *Untitled,* 1962
collage on paper, 47⅛ x 11

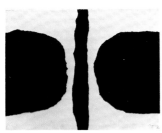

29. *Untitled,* 1962
collage on paper, 22 x 30⅛

30. *Untitled,* 3/1965
graphite on paper, 30 x 42½

31. *Untitled,* 1965
crayon and acrylic, 30 x 42½

32. *Untitled,* 7/1966
tempera on paper, 21¼ x 30

33. *Untitled,* 8/1966
tempera on paper, 21⅜ x 30

34. *Untitled,* 8/1966
tempera on paper, 21¼ x 30

35. *Untitled,* 8/1966
tempera on paper, 21 x 30⅛

36. *Untitled,* 11/1966
acrylic on paper, 19⅛ x 26

37. *Untitled,* 1969
lithograph, trial proof,
22¼ x 30

38. *Untitled,* 1969
acrylic and crayon on paper,
25¼ x 38

39. *Untitled,* 3/1969
acrylic and pencil on paper,
22⅛ x 30

40. *Untitled,* 4/1969
acrylic and graphite on paper,
42¾ x 30

41. *Wall Form,* 4/1969
acrylic and graphite on paper,
20 x 21¾

42. *Untitled,* 7/1969
crayon and acrylic on paper,
40 x 26

43. *Untitled,* 10/1969
acrylic on paper, 35 x 46

44. *Untitled,* 10/1969
acrylic and crayon on paper,
35 x 35

45. *Untitled,* n.d.
graphite on paper, 25¼ x 38

46. *Untitled,* 1/1970
acrylic on paper, 36 x 25½

47. *Untitled,* 7/1970
acrylic on paper, 35 x 46

48. *Untitled*, 11/1970
graphite and acrylic on paper,
35 x 46

49. *Untitled*, 12/1970
acrylic on paper, 35 x 46

50. *Untitled*, 12/1970
acrylic on paper, 40 x 26

51. *Untitled*, 1971
acrylic on paper, 37 x 26¼

54. *Untitled*, 3/1971
acrylic on paper, 35 x 46

55. *Untitled*, 10/1971
tempera on paper, 35 x 46

52. *Untitled*, 1971
tempera on paper, 46 x 35

53. *Untitled*, 2/1971
acrylic on paper, 42 x 30

56. *Baltimore*, 1/1975
acrylic and pencil on paper,
35⅛ x 45

57. *Untitled*, 11/1975
acrylic on paper, 26⅛ x 39¾

58. *Untitled*, 12/1975
acrylic on paper, 26¼ x 40

59. *Untitled*, 6/1976
graphite and crayon on paper,
25¼ x 38

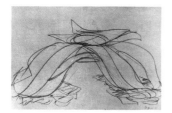

60. *Untitled*, 1977
graphite on paper, 20 x 30

61. *Untitled*, 2/1978
acrylic on paper, 40 x 30

62. *Untitled*, 2/1978
acrylic on paper, 30 x 40

63. *Untitled*, 5/1978
acrylic on paper, 35 x 46

64. *Untitled*, 12/1978
acrylic and pencil on paper,
35⅛ x 45

65. *Untitled*, 1979
graphite on paper, 22½ x 35

66. *Untitled*, 1979
graphite on paper, 11¼ x 17½

67. *Untitled*, 1981
oil on paper, 50 x 38

68. *Untitled*, 1981
oil on paper, 50⅛ x 38

Drawings are from the collection of the artist, courtesy Robert Miller Gallery.

George Sugarman Chronology

1912
born 11 May, the Bronx, New York to Herman and Laura Sugarman. Father was an Oriental rug dealer, mother interested in music. Sugarman in middle of family of three sisters and one brother.

1920–27
attended concerts with aunts and sisters, exposed to theater —aunt took him backstage at Philadelphia's Hedgerow Theatre

accompanied father on rug-selling trips throughout Eastern and Southern states—the colors and patterning of Persian and Turkish rugs made a lasting impression

1928
graduated from Bronx Morris High School

avidly attended Broadway plays

enrolled in New York City College

1934
awarded B.A. from New York City College, 1 February

1935–40

supported himself with a variety of jobs—taught arts and crafts for WPA; welfare department investigator

1941–45
served in the U.S. Navy—assigned to hospital in Pacific theater—tour of duty included Guadalcanal and Tulagi

1945–51
attended evening art classes at Museum of Modern Art, spent a great deal of time sketching New Yorkers in subways, parks, and on the street

1951–52
studied with Cubist sculptor, Ossip Zadkine, in Paris—only formal art training

1952–55
utilized facilities of Académie de la Grande Chaumière, met Al Held and Chuck Ginnever

Three Abstract Forms—first piece of "floor sculpture" (1953)

traveled widely in Europe—impressed with Baroque architecture, Velasquez paintings in the Prado, and Gaudí's Cathedral in Barcelona

exhibited with Salon de la Jeune Sculpture in Paris

explored the possibilities of multi-part sculpture

1955
returned to New York—fresh impression of New York's architectural diversity as compared with Paris' unity

took a studio on E. 23rd St. in New York near Al Held, Ron Bladen, and Yvonne Rainer

Many Harbors, Many Reefs—first sculpture exploring the possibilities of laminating wood

1957
joined the cooperative Brata Gallery

helped found the New Sculpture Group

1958
exhibited with Brata Gallery, three-man show

Hansa Gallery exhibit—first show of the New Sculpture Group

first one-man show, Union Dime Savings Bank, New York and first review (Lawrence Campbell in *Art News*)

met Sam Francis

1959
first commission, Wall Sculpture, CIBA-GEIGY Corporation, Ardsley, New York

exhibited with Sam Francis, Watch Hill, Rhode Island

Yellow Top—first polychrome sculpture, completed 31 December

1960
first gallery show at Widdifield Gallery, New York

hired by Hunter College, City University of New York graduate school as adjunct professor of sculpture (until 1970)

1961

exhibited in Pittsburgh International, Carnegie Institute, Pittsburgh, Pennsylvania—awarded second prize for *Six Forms in Pine*

Blue, Black and White—first successful sculpture using more than one family of forms

awarded Longview Foundation Grant (also in 1962 and 1963)

1962

piece purchased by Sam Francis

1963

exhibited at Sao Paulo Bienal, Brazil

1964

met Amy Goldin

Inscape—first field sculpture using dissociating forms

1965

awarded Ford Foundation grant for work in Tamarind lithography workshop

1966

received National Foundation of the Arts Award

Two in One—largest, most complex work in wood

1967

visiting associate professor of sculpture, Yale School of Art

Brad Davis hired as assistant

commission received for first outdoor sculpture, *From Yellow to White to Blue to Black*, for a plaza in El Segundo, California

1968

Square Spiral—first metal sculpture made in partnership with Lippincott, Inc.

commission received for First National Bank of St. Paul, Minnesota—first piece conceived specifically for the site

1969

first major European retrospective, exhibited at Kunsthalle, Basel; Städtisches Museum, Leverkusen; Haus am Waldsee, Berlin; Stedelijk Museum, Amsterdam

Ten—last piece worked on by Brad Davis and Sugarman's last wood sculpture to date

1970

Amy Goldin and Robert Kushner visit Greene St. studio while St. Paul commission is being completed

From Yellow to White to Blue to Black installed in the plaza of the Xerox Building, El Segundo, California

guest artist at St. Cloud State University, St. Cloud, Minnesota, and Hamline University, St. Paul, Minnesota

1971

First National Bank of St. Paul commission installed—first piece integrated into the architecture of the building

started "pattern" paintings

continued sculptural concerns with painted metal

1975

"People Sculpture"—General Services Administration commission installed at Baltimore Federal Building, first piece to integrate people into the sculptural space

1976

began making relief collages

exhibited in first decorative exhibition, *"Ten Approaches to the Decorative,"* at the Alessandra Gallery, New York

1981

first Milton Avery Professor of Art at Bard College, Annandale-on-Hudson, New York

Exhibitions Chronology and Bibliography

ONE-MAN EXHIBITIONS

1958

Union Dime Savings Bank, Sixth Avenue Branch, New York. "New York is *the* Textile Town". December through January 1959.
Campbell, Lawrence. "Reviews and Previews: New Names This Month: George Sugarman." *Art News* 57 (February 1959):17.

1960

Widdifield Gallery, New York. *Sugarman Sculpture.* Sculpture, collages, and drawings. February 9 through March 5.
Dennison, George. "In the Galleries: George Sugarman." *Arts* 34(February 1960):65.
Schuyler, James. "Reviews and Previews: George Sugarman." *Art News* 58 (February 1960):15.

1961

Stephen Radich Gallery, New York. *Sugarman Polychrome Sculpture.* October 31 through November 24.
Campbell, Lawrence. "Reviews and Previews: George Sugarman." *Art News* 60(December 1961):12.
Sawyer, Kenneth. "Painting and Sculpture, The New York Season." *Craft Horizons* 22 (May/June 1962):52.
Tillim, Sidney. "New York Exhibitions/In the Galleries: George Sugarman." *Arts* 36(December 1961):52.

1964

Stephen Radich Gallery, New York. Sculpture. March 10 through April 4.
Ashton, Dore. "New York Commentary: No Post-Painterly Painting." *Studio International* 168(July 1964):42.
Edgar, Natalie. "Reviews and Previews: George Sugarman." *Art News* 63(May 1964):10.
Lippard, Lucy R. "New York: George Sugarman, Stephen Radich." *Artforum* 2(May 1964):53.

1965

Stephen Radich Gallery, New York. Lithographs done at the Tamarind Lithography Workshop. November 13 through December 4.
Swain, Richard. "Reviews/In the Galleries: George Sugarman." *Arts* 40(February 1966):66.

1966

Stephen Radich Gallery, New York. Sculpture. May 3–28.
Ashton, Dore. "New York Commentary: The 'Anti-Compositional Attitude' in Sculpture." *Studio International* 172(July 1966):44.

Dayton's Gallery 12, Minneapolis. *Sugarman: Sculpture, Lithographs.** November 15 through December 10. Catalogue: text by Sidney Simon. Reprinted as "George Sugarman" in *Art International* 11(May 1967):22.

1967

Fischbach Gallery, New York. Oil paintings on paper. May 6–27.
Burton, Scott. "Reviews and Previews: George Sugarman." *Art News* 66(May 1967):56.
Siegal, Jeanne. "Reviews/In the Galleries: George Sugarman." *Arts* 41(May 1967):56.

Galerie Renée Ziegler, Zurich. Polychrome sculpture. June 29 through July 29.
Curjel, Hans. "Werk-chronik Zurich: Georges Sugarman, Galerie Renée Ziegler." *Werk* 54(September 1967):602.

Galerie Schmela, Düsseldorf. Polychrome sculpture. September 25 through October 20.

1968

Fischbach Gallery, New York. *George Sugarman: New Sculpture.* April 13 through May 9.
Ashton, Dore. "New York Commentary: George Sugarman at Fischbach." *Studio International* 175 (June 1968):321.
Brown, Gordon. "Month in Review: Sugarman, Henselmann, Gee and Noguchi." *Arts* 42(May 1968):53.
——————. "Images: Sugarman at Fischbach." *Arts* 42(April 1968):20.
Pomeroy, Ralph. "Reviews and Previews: George Sugarman." *Art News* 67(May 1968):60.
Wasserman, Emily. "New York: George Sugarman, Fischbach." *Artforum* 6(Summer 1968):57.

1969

Fischbach Gallery, New York. *George Sugarman: New Sculpture.* April 5–24.
Ashbery, John. "Reviews and Previews: George Sugarman." *Art News* 68(May 1969):73.

Ashton, Dore. "New York Commentary: George Sugarman at Fischbach Gallery." *Studio International* 177(June 1969):289.

Pincus-Witten, Robert. "New York: George Sugarman." *Artforum* 7(Summer 1969):62.

Schjeldahl, Peter. "New York Letter." *Art International* 13 (Summer 1969):68.

Simon, Rita. "Reviews/In the Galleries: George Sugarman." *Arts* 43(May 1969):60.

Kunsthalle, Basel, Switzerland. Plastiken, Collagen, Zeichnungen. Retrospective. September 21 through October 26. Catalogue: texts by Amy Goldin and Peter F. Althaus, in German and English.* *Traveled to:* Städtisches Museum, Leverkusen, West Germany, November 28 through January 4, 1970; Haus am Waldsee Museum, Berlin, January 16 through February 22, 1970; and Stedelijk Museum, Amsterdam, March 14 through April 26, 1970. Catalogue: text by Irving H. Sandler, a Dutch translation of "Sugarman Makes a Sculpture." Art News 65(May 1966):34.*

Jehle, W. "Ausstellungen in Basel: Basler Kunstchronik." *Werk* 56(December 1969):874.

Kress, Peter. "Ausstellungen: George Sugarman." *Das Kunstwerk* 23(February/March 1970):48.

Szeemann, Harald. "George Sugarman." *Art International* 14(February 1970):50.*

1971

Gallery 118, Minneapolis. Drawings. May 7–30. Invitation with statement on drawing by the artist.

1974

Zabriskie Gallery, New York. Polychrome steel and aluminum sculpture. October 8 through November 9. Catalogue with statement by the artist.

Brown, Gordon. "Arts Reviews: George Sugarman." *Arts* 49(December 1974):18.

Kaplan, Patricia. "Reviews: George Sugarman." *Art News* 73(December 1974):90.

Schwartz, Barbara. "Exhibitions: New York Sculpture." *Craft Horizons* 35(February 1975):58.

Taylor, John Lloyd. "Reviews of Exhibitions/New York: George Sugarman at Zabriskie Gallery and Hammarskjöld Plaza." *Art in America* 62(November/December 1974):122.

Dag Hammarskjöld Plaza Sculpture Garden, New York. Sculpture. October 21 through December 31. Brochure.

1977

Robert Miller Gallery, New York. Sculpture. November 15 through December 3.

1978

Robert Miller Gallery, New York. Relief collages. December 2 through January 3, 1979.

Kramer, Hilton. "Also on View This Week: George Sugarman." *New York Times*, 15 December 1978, p. C22.

1979

Galerie Liatowitsch, Basel, Switzerland. Collages. February 7–28.

1980

Robert Miller Gallery, New York. *Relief Collages and Models for Large Scale Sculpture*. January 5–26. Documented in the catalogue *Robert Miller, New York, 1979 to 1980*.

Beatty, Frances. "Arp and Sugarman Exhibited." *Art/World* 4(18 January, 1980):1.

Frank, Elizabeth. "Review of Exhibitions/New York: George Sugarman at Robert Miller." *Art in America* 68 (April 1980):133.

Friedman, Jon R. "Arts Reviews: George Sugarman." *Arts* 54(April 1980):22.

Glueck, Grace. "Art: Lyrical Sculptures of George Sugarman." *New York Times*, 18 January 1980, p. C17.

Rickey, Carrie. "Voice Arts." *Village Voice*, 9 January 1980, p. 81.

Galerie Rudolf Zwirner, Cologne. *George Sugarman: New Works*. Collages. November 15 through December 31.

1981

Museum of Fine Arts, Springfield, Massachusetts. *The Sculpture of George Sugarman*. April 5 through May 17. Catalogue. Traveled to: Museum of Art, Munson-Williams-Proctor Institute, Utica, New York, May 30 through August 23.

Smith Andersen Gallery, Palo Alto, California. September 12 through October 24.

Pratt Manhattan Center Gallery, New York. *For Love and Money: Dealers Choose*. September 14 through October 10.

GROUP EXHIBITIONS

1952

Musée Rodin, Paris. *IV° Salon de la Jeune Sculpture*. Annual exhibition. May 30 through June 30. Brochure.

1954

Musée des Beaux-Arts, Paris. *9° Salon des Réalitiés Nouvelles*. June 8 through August 8. Catalogue.

Musee Rodin, Paris. *VI° Salon de la Jeune Sculpture*. Annual exhibition. Brochure.

1956

Tanager Gallery, New York. *Sculptors Selected by Painters*.

1957

Brata Gallery, New York. *Group Show*. October 25 through November 14.

1958

Brata Gallery, New York. Three-person show.

Hansa Gallery, New York. *New Sculpture Group*.

1959

Silvermine Guild of Artists, New Canaan, Connecticut. *The Ninth Annual New England Exhibition*. June 8 through July 10. Catalogue.

Widdifield Gallery, New York. *Mixed Mediums*.
Three-person show with Raymond Herdler and Matsumi
Kanemitsu. November 10 through December 5.
> J. (Judd), D. (Donald). "Reviews and Previews: Mixed
> Mediums." *Art News* 58(November 1959):60.

Galerie Raymond Creuze, Paris. *American Artists*. Exchange
exhibition arranged by Brata Gallery.

Stable Gallery, New York. *New Sculpture Group*.

Scarborough, New York. *Wood Memorial Annual*.

Watch Hill, Rhode Island. Two-person show with
Sam Francis.

1960
Dwight Hall, Mount Holyoke College, South Hadley, Mas-
sachusetts. *New Sculpture Now*. February 22 through March
24. Catalogue. Traveled to: Museum of Art, Smith College,
Northampton, Massachusetts, April 6 through May 9.

Stable Gallery, New York. *New Sculpture Group*. September
27 through October 15.

Galerie Claude Bernard, Paris. *Aspects de la Sculpture
Américaine*. October. Catalogue.
> Restany, Pierre. "Ausstellungen: Paris im Oktober 1960."
> *Kunstwerk* 14(November/December 1960):76.

Whitney Museum of American Art, New York. *Annual
Exhibition: Contemporary American Sculpture and Drawing*.
December 7 through January 22, 1961. Catalogue.
> Coates, Robert M. "The Art Galleries: Sculpture Annual."
> *The New Yorker*, 17 December 1960, p. 101.

"Longview Foundation Exhibition." Traveled to Hayden
Gallery, Massachusetts Institute of Technology, 1961.

1961
Holland-Goldowski Gallery, Chicago. *New Sculpture Group*.
March 10 through April 6.

Walker Art Center, Minneapolis. *Eighty Works from the Richard
Brown Baker Collection*. March 12 through April 16.
Catalogue.

Lever House, New York. *Sculpture Guild Annual*. October 17
through November 12. Catalogue.

Museum of Art, Carnegie Institute, Pittsburgh. *Pittsburgh
International: Exhibition of Contemporary Paintings and
Sculpture*. October 27 through January 7, 1962. Catalogue:
text by Gordon Washburn.
> Frigero, S. "Les Expositions à l'Etranger: L'Exposition
> International de Pittsburgh et les Prix de l'Institute
> Carnegie." *Aujourd'hui: Art et Architecture* 6(December
> 1961):62.
> _____ . "Il Premo Carnegie 1961." *Domus* 386
> (January 1962):25.

Stephen Radich Gallery, New York. *Sculptor's Drawings at
Stephen Radich*.

Stable Gallery, New York. *New Sculpture Group*.

1963
Art Institute of Chicago. *65th Annual American Exhibition:
Some Directions in American Painting and Sculpture*. January 5
through February 18. Catalogue.

Art Gallery, Vassar College, Poughkeepsie, New York. *Con-
temporary Sculpture*. February 21 through March 20.

Wadsworth Atheneum, Hartford, Connecticut. *Continuity
and Change: 45 American Abstract Painters and Sculptors*. April
12 through May 27. Catalogue: text by Sam Wagstaff, Jr.

Fine Arts Pavilion, Seattle World's Fair. *Art Since 1950,
American and International*. April 21 through October 21.
Catalogue: text by Sam Hunter. (The American portion of
this exhibition was divided into two parts which were si-
multaneously exhibited at the Poses Fine Arts Institute, now
the Rose Art Museum, Brandeis University, Waltham,
Massachusetts, and the Institute of Contemporary
Art, Boston, November 21 through December 23. Although
Sugarman's piece did not travel to either of these places,
his work is discussed in the catalogue *American Art
since 1950*, which was adapted from the Seattle catalogue
for the Massachusetts exhibitions.)

VII Bienal de São Paulo, Brazil. American Section. *Ten Amer-
ican Sculptors*.* September 28 through December 31. Orga-
nized by the Walker Art Center. Catalogue. Traveled to:
Walker Art Center, Minneapolis, March 10 through April 19,
1964; San Francisco Museum of Modern Art, May 4 through
July 1, 1964; City Art Museum, St. Louis, July 21 through
August 23, 1964; Dayton Art Institute, Ohio, October 16
through November 22, 1964.
> Kozloff, Max. "Nationwide Reports/Minneapolis: Ameri-
> can Sculpture in Transition." *Arts* 38(May/June 1964):1.
> Stiles, Knute. "Sculpture for São Paulo." *Artforum* 3
> (September 1964):44.

Heckscher Museum, Huntington Township Art League,
Huntington, Long Island, New York. *Second Annual Sculpture
Show*. September 30 through October 28.

Cohen Memorial Museum of Art, George Peabody College
for Teachers (now part of Vanderbilt University), Nashville.
American Sculpture 1962 to 1963. October 15 through
December 1. Brochure: text by Sidney Geist. Traveled to:
University of Tennessee, Knoxville, January 2 through
February 8, 1964; Hendrix College, Conway, Arkansas,
February 22 through March 29, 1964; University of Alabama,
Tuscaloosa, April 12 through May 17, 1964.

1964
Park Place Gallery, New York. Invitational show.

Howard Wise Gallery, New York. *Ten Sculptors from the São
Paolo Biennial*. March 5–28.

U.S. Pavilion, World's Fair, New York. American Sculpture
Exhibition. Summer. Catalogue.

Jewish Museum, New York. *Recent American Sculpture*.
October 14 through November 29. Catalogue: text on
Sugarman by Irving Sandler.
> Ashton, Dore. "New York Commentary: Unconventional
> Techniques in Sculpture." *Studio International* 169(January
> 1965):22.
> Raynor, Vivian. "In the Galleries: Recent American
> Sculpture." *Arts* 38(December 1964):67.
> Rose, Barbara. "New York Letter: Recent American
> Sculpture." *Art International* 8(December 1964):47.

New School Art Center, New School for Social Research, New York. *Artist's Reality: An International Sculpture Exhibition*. October 14 through Novembr 14. Catalogue with statement by the artist.

Hayden Gallery, Massachusetts Institute of Technology, Cambridge. *Seven Sculptors*. November 9 through December 7.

Contemporary Arts Association, Houston, *Dealer's Choice*. December 3–29.

Whitney Museum of American Art, New York. *Annual Exhibition 1964: Contemporary American Sculpture*. December 9 through January 31, 1965. Catalogue.
 Kozloff, Max. "The Further Adventures of American Sculpture." *Arts* 39(February 1965):24.
 O'Doherty, Brian. "Whitney Sculpture Biennial: Possible Futures." *Newsweek*, 18 January 1965, p. 74. Reprinted in the author's *Object and Idea: An Art Critic's Journal, 1961 to 1967*. New York: Simon and Schuster, 1967.

1965
Flint Institute of Arts, Michigan. *American Sculpture 1900 to 1965*. April 1–25. Catalogue.

Sheldon Memorial Art Gallery, University of Nebraska, Lincoln. *Nebraska Art Association Annual*. April 4 through May 2. Catalogue.

Loeb Student Center, New York University, New York. *Concrete Expressionism.** April 6–29. Catalogue: text by Irving Sandler. Reprinted as "Expressionism With Corners." *Art News* 64(April 1965):38.
 Ashton, Dore. "New York Commentary." *Studio International* 170(August 1965):86.
 ⎯⎯⎯⎯⎯⎯. "Art." *Arts and Architecture* 82(June 1965):10–11.
 Kozloff, Max. "Art: The Variables of Energy." *The Nation* 200(May 1965):513.
 Lippard, Lucy R. "New York Letter." *Art International* 9(June 1965):51.

American Embassy, Mexico City. *Art in Embassies*. Organized by The Museum of Modern Art, New York. Opened July 15.

American Embassy, Helsinki. *Art in Embassies*. Organized by The Museum of Modern Art, New York. Opened September 14.

American Federation of Arts, New York. *Colored Sculpture*. Brochure. Traveled to: Cranbrook Academy of Art, Bloomfield Hills, Michigan, October 5–26; Arnot Art Gallery, Elmira, New York, November 10–30; Portland Museum of Art, Portland, Maine, December 9 through January 4, 1966; Montclair Art Museum, New Jersey, January 16 through February 8, 1966; Madison Art Center, Wisconsin, February 23 through March 15, 1966; Fresno State College, California, March 30 through April 24, 1966; Long Beach Museum of Art, California, May 8–29, 1966; University of Iowa, Iowa City, June 14 through July 5, 1966; Witte Memorial Museum, San Antonio, October 11 through November 1, 1966; University of North Carolina, Chapel Hill, November 15 through December 6, 1966; Coe College, Cedar Rapids, Iowa, January 24 through February 14, 1967; Contemporary Arts Association (now Contemporary Arts Museum), Houston, February 28 through March 21,

1967; University of Florida, Gainesville, May 9–30, 1967; University of Massachusetts, Amherst, June 13 through July 11, 1967; Ithaca College, New York, September 5–26, 1967; State University College at Potsdam, New York, October 10–31, 1967.

1966
Art Institute of Chicago. *26th Annual Exhibition by the Society of Contemporary American Art*. April 8 through May 10. Catalogue.

Whitney Museum of American Art, New York. *Art of the United States: 1670 to 1966*. September 27 through November 27. Catalogue: text by Lloyd Goodrich.

Drexel Institute of Technology (now Drexel University), Philadelphia. *Art 75: 75th Anniversary Exhibition of Contemporary Painting and Sculpture*. November 9 through December 2.

Whitney Museum of American Art, New York. *Annual Exhibition, 1966: Contemporary American Sculpture and Prints*. December 16 through February 5, 1967. Catalogue.
 Adrian, Dennis. "Sculpture and Print Annual, Whitney Museum." *Artforum* 5(March 1967):55.

1967
England and Yugoslavia. *American Print Show*. A traveling exhibition organized by Gene Baro.

Wilmington Society of the Fine Arts (now the Delaware Arts Center), Wilmington, Delaware. *Contemporary American Painting and Sculpture from New York Galleries*. February 24 through March 19.

Yale University Art Gallery, New Haven, Connecticut. *The Helen W. and Robert M. Benjamin Collection*. May 4 through June 18.

Los Angeles County Museum of Art, Los Angeles. *Sculpture of the Sixties.** April 28 through June 25. Catalogue: texts by various authors with statements by the artists; in particular the essay by Irving Sandler, "Gesture and Non-Gesture in Recent Sculpture," p. 40. Reprinted in Battcock, Gregory, ed. *Minimal Art, A Critical Anthology*. New York: E. P. Dutton, 1968, p. 308. Traveled to: Philadelphia Museum of Art, September 15 through October 19.

1968
Modern Art Museum, Munich. *Neue Kunst U.S.A.: Barock-Minima*. Catalogue: text by Yvonne Hagen.

Foundation Maeght, St. Paul de Vence, France. *L'Art Vivant 1965–68*. April 13 through June 30. Catalogue: text by François Wehrlin.

International Pavilion, Venice Biennial. June 22 through October 20. Catalogue.

Whitney Museum of American Art, New York. *1968 Annual Exhibition: Contemporary American Sculpture*. December 17 through February 9, 1969. Catalogue.
 Ashton, Dore. "New York Commentary." *Studio International* 177(March 1969):135.
 Art Now: New York 1(January 1969). Color illustration of *Square Spiral* and a statement by the artist about this work on the occasion of its inclusion in the Whitney Annual.*

1969

University Gallery, University of Minnesota, Minneapolis. *The Artist and the Factory, Drawings and Models: A Loan Exhibition*. March 19 through April 16. Catalogue.

The Museum of Modern Art, New York. *Tamarind: Homage to Lithography*. April 29 through June 30. Catalogue: texts by William S. Lieberman and Virginia Allen.

Michigan Council for the Arts, Detroit. *Sculpture Downtown*. Outdoor summer exhibition.

Grand Rapids Museum, Michigan. *Contemporary American Sculpture*. September 8 through December 3.

1970

Delaware State Arts Council, Wilmington. Outdoor sculpture exhibition in Rodney Square (two-person with Bernard Rosenthal). May 26 through August 12.

Foundation Maeght, St. Paul de Vence, France. *L'Art Vivant aux Etats-Unis*. July 16 through September 30. Catalogue.

Contemporary Arts Center, Cincinnati. *Monumental Art*. September 13 through November 1. Catalogue.
 Alloway, Lawrence. "Monumental Art at Cincinnati." *Arts* 45(November 1970):33.

Sheldon Memorial Art Gallery, University of Nebraska, Lincoln. *American Sculpture*. September 11 through November 15. Catalogue: text by Norman A. Geske.

Whitney Museum of American Art, New York. *1970 Annual Exhibition: Contemporary American Sculpture*. December 12 through February 7, 1971. Catalogue.

1971

French & Co., New York. *Contemporary American Drawings*. May 15 through June 23.

Middelheim Open-Air Museum of Sculpture, Antwerp. *11th Biennial of Outdoor Sculpture*. June 6 through October 3. Catalogue.

City Hall Plaza, Boston. *Monumental Sculpture*. October 2 through November 14.

1972

Massachusetts Institute of Technology, Cambridge. *Outdoor Sculpture*. June 6 through October 3.

1973

Whitney Museum of American Art, New York. *Contemporary American Art: 1973 Biennial Exhibition*. January 10 through March 18. Catalogue.

Jaffe Friede Gallery, Hopkins Center, Dartmouth College, Hanover, New Hampshire. *Woodworks: An Exhibition of Contemporary Sculpture in Wood*. December 7 through January 14, 1974. Catalogue: text by Churchill P. Lathrop. Traveled to: Addison Gallery of American Art, Phillips Academy, Andover, Massachusetts, January 18 through February 24, 1974; Institute of Contemporary Art, Boston, March 1–26, 1974; Paul Creative Arts Center, University of New Hampshire, Durham, April 4 through May 3, 1974; William Benton Museum of Art, University of Connecticut, Storrs, May 25 through August 11, 1974; Bowdoin College Museum of Art, Brunswick, Maine, August 16 through September 27, 1974.

1974

One Illinois Center, Chicago. *Space, Scale, and Urban Plaza: Sculpture for the Plaza*. June 14 through September 14.
 Artner, Alan G. "Norwegian Ice: Floating in Sensuous Color." *Chicago Tribune*, 23 June 1974, sec. 6, p. 6.
 Adrian, Dennis. "Sculpture Goes Outside With Zest and Power." *Chicago Daily News*, 22–23 June, 1964, "Panorama," p. 12.

Zabriskie Gallery, New York. Group show. June 25 through July 20. Traveled to: Philadelphia Art Alliance, March 8 through April 5; Glassboro State College, New Jersey, April 9 through May 5.

Monumenta Newport, Inc., Rhode Island. *Monumenta: A Biennial Exhibition of Outdoor Sculpture*. August 17 through October 13. Catalogue: text by Sam Hunter.

Landmark Gallery, New York. *118 Artists*. December 22 through January 10, 1975.

1975

Clocktower (Institute for Art and Urban Resources), New York. *Artists Make Toys*. Opened January 1. Catalogue.

Portland Art Museum, Oregon. *Masterworks in Wood: The Twentieth Century*. September 17 through October 19. Catalogue: text by Jan van der Marck.

Fine Arts Center Gallery, University of Massachusetts, Amherst. *Artist and Fabricator*. September 23 through November 9. Catalogue: text by Hugh Marlais Davies.

National Collection of Fine Arts, Smithsonian Institution, Washington, D.C. *Sculpture: American Directions 1945 to 1975*. October 3 through November 30. Catalogue. Traveled to: Dallas Museum of Fine Arts, January 21 through February 29, 1976; New Orleans Museum of Art, April 1 through May 16, 1976.

Kansas State College at Pittsburgh. *Working Drawings by Sculptors*. November 3–21.

1976

Whitney Museum of American Art, New York. *200 Years of American Sculpture*. March 16 through September 26. Catalogue: texts by various authors.

Ingber Gallery, New York. *The Small Sculpture Show*. March 22 through April 9. Traveled to: Weatherspoon Art Gallery, University of North Carolina, Greensboro, October 9 through November 6, 1977.

New Orleans Museum of Art. *Fine Arts in New Federal Buildings*. April 1 through May 16. Catalogue. Organized by the General Services Administration, Washington, D.C.

Alessandra Gallery, New York. *Ten Approaches to the Decorative*. September 25 through October 29.
 Perrone, Jeff. "Approaching the Decorative." *Artforum* 15 (December 1976):26.

Pleiades Gallery and the Association of Artist-run Galleries, New York. *Tenth Street Days: The Co-ops of the 50s*. December 20 through January 7, 1977. Catalogue: texts by various authors. An artist-initiated exhibition of works from 1952 to 1962 that had been exhibited in the co-operative galleries Tanager, Hansa, James, Camino, March, Brata, Phoenix, and Area. Exhibited at the co-operative galleries Amos Eno,

14 Sculptors, Noho, Pleiades, and Ward-Nasse. Traveling version of the exhibition toured New York State for two years under the sponsorship of the Gallery Association of New York State.

1977

Brainerd Art Gallery, State University College at Potsdam, New York. *Sculpture Potsdam '77*. February 25 through March 24. Catalogue.

North Art Gallery, American Academy of Arts and Letters, New York. *Exhibition of Works by Candidates for Art Awards*. March 14 through April 9.

Monique Knowlton Gallery, New York. *Maquettes for Large Sculpture*. March 30 through April 30.

Wave Hill Sculpture Garden, Bronx, New York. May through October. Catalogue.

Akron Art Institute (now Akron Art Museum), Ohio. *Project: New Urban Monuments*. May 1 through June 19. Catalogue: text by Robert Doty. Traveled to: Columbus Gallery of Fine Arts, Ohio, July 15 through September 25; Contemporary Arts Center, Cincinnati, October 8 through November 27; Tennessee Botanical Gardens and Fine Arts Center, Nashville, January 7 through February 25, 1978; Museum, Cranbrook Academy of Art, Bloomfield Hills, Michigan, March 5 through April 16; University of Michigan Museum of Art, Ann Arbor, May 12 through September 10; Krannert Art Museum, University of Illinois, Urbana, October 7 through November 5; Edwin A. Ulrich Museum of Art, Wichita State University, Kansas, December 1 through January 31, 1979.

The Museum of the American Foundation for the Arts, Miami. *Patterning and Decoration*. October 7 through November 30. Catalogue: text by Amy Goldin.

1978

Miami-Dade Community College. *Artists' Sketchbooks and Preparatory Drawings*. January 5–25.

1979

Robeson Center Gallery, Newark College of Arts and Sciences, Rutgers University, Newark, New Jersey. *Green Magic II: Plant Forms in Art of the 70s*. April 9 through May 5.

The Museum of Modern Art, New York. *Contemporary Sculpture from the Collection*. May 18 through August 7. Catalogue.

Institute of Contemporary Art, University of Pennsylvania, Philadelphia. *The Decorative Impulse*. June 13 through July 21. Catalogue: text by Janet Kardon and statement by the artist. Traveled to: Mandeville Art Gallery, University of California, San Diego, November 1 through December 9; Minneapolis College of Art and Design, January 16 through February 15, 1980; The Museum of Contemporary Art, Chicago, March 21 through May 18, 1980.
> McDonald, Robert. "The Sensual Side of Experience." *Artweek* 10(November 24, 1979):5.

1980

Joe and Emily Lowe Art Gallery, College of Visual and Performing Arts, Syracuse University. *Current/New York*. January 27 through February 24. Catalogue.

Whitney Museum of American Art, Downtown Branch, New York. *Painting in Relief*. January 30 through March 5. Catalogue: text by Lisa Phillips.

Max Hutchinson Gallery, New York. *Ten Abstract Sculptures: American and European, 1940 to 1980*. March 18 through April 19. Catalogue.

Institute of Contemporary Art, University of Pennsylvania, Philadelphia. *Urban Encounters: Art, Architecture, Audience*. March 19 through April 30. Catalogue: texts by various authors.

State University of New York, College at Amherst. *Five Sculptures for Outdoors*. April 1980 through April 1981. Organized by Nina Freudenheim Gallery, Buffalo.

National Collection of Fine Arts (now the National Museum of American Art), Smithsonian Institution, Washington, D.C. *Across the Nation: Fine Art for Federal Buildings, 1972–1979*. June 4 through September 1. Catalogue. Traveled to: Hunter Museum of Art, Chattanooga, January 11 through March 1, 1981; Laumeier International Sculpture Park, St. Louis, June 21 through August 11, 1981; University of Arizona Museum of Art, Tucson, September 6 through October 11, 1981; Sarah Campbell Blaffer Gallery of the University of Houston, Texas, November 6 through December 18, 1981.
> Stevens, Mark. "Sculpture Out in the Open." *Newsweek* 96(August 18, 1980):70.

Indianapolis Museum of Art. *Painting and Sculpture Today*. June 24 through August 17. Catalogue: compiled and edited by Hilary Bassett, Judith McKenzie, and Robert Yassin.

Palo Alto Cultural Center, California. *Painted Sculpture*. August 31 through October 26.

Albright-Knox Art Gallery, Buffalo. *With Paper, About Paper*. September 12 through October 26. Catalogue: text by Carlotta Kotik.

P.S. 1 (Institute for Art and Urban Resources), Brooklyn, New York. *Watercolors*. December 7 through January 25, 1981. Catalogue: texts by various authors.

1981

Sculpture Center, New York. *Decorative Sculpture*. January 11 through February 20.
> Perreault, John. "The Not Plainer Dimension." *Soho Weekly News*, 28 January 1981, p. 56.

Max Hutchinson Gallery, New York. *Sculptors: Drawings and Maquettes*. January 13 through February 14.
> Russell, John. "Sculptors: Drawings and Maquettes." *New York Times*, 6 February 1981, sec. 3, p. 17.*

McIntosh/Drysdale Gallery, Washington, D.C. *The Decorative Image*. March 7 through April 2.

Myers Fine Arts Gallery, State University College at Plattsburgh, New York. *Usable Art*. March 24 through May 3. Catalogue: text by John Perreault. Scheduled to travel to: Queens Museum, Flushing, New York, August 1 through September 27; Brainerd Art Gallery, State University College at Potsdam, New York, October 11 through November 1; Danforth Museum, Framingham, Massachusetts, December 6 through February 14, 1982.

Stamford Museum and Nature Center, Stamford, Connecticut. *Classic Americans*. June 14 through September 7. Catalogue.

ARTICLES, INTERVIEWS, AND STATEMENTS BY THE ARTIST

Ashton, Dore. "Art U.S.A. 1962." *The Studio* 163(March 1962):84.

Baker, Kenneth. "The Home Forum." *Christian Science Monitor*, 21 October 1969, p. 8.

Bongartz, Roy. "Where Monumental Sculptors Go." *Art News* 75(February 1976):34.

Castle, Wendell. "Wood: George Sugarman." *Craft Horizons* 27(March 1967):30-33.*

Cummings, Paul. "Interview: George Sugarman Talks with Paul Cummings." *Drawing* 2(January/February 1981):106*.

Glaser, Bruce; Kipp, Lyman; Sugarman, George; and Weinrib, David. "Where Do We Go From Here?" *Contemporary Sculpture: Arts Yearbook 8*. New York: The Art Digest, 1965, p. 150. Transcript of a panel discussion which was moderated by Mr. Glaser and broadcast over radio station WBAI, New York.*

Goldin, Amy. "Beyond Style." *Art and Artists* 3(September 1968):32–35.*

_____ . "The Sculpture of George Sugarman." *Arts* 40(June 1966):28–31.*

Harper, Paula. "George Sugarman: The Fullness of Time." *Arts* 55(September 1980):158–160.*

Harney, Andy Leon. "Proliferating One Percent Programs for the Use of Art in Public Buildings." *American Institute of Architects Journal* 65(October 1976):35.

Hess, Thomas B. "U.S. Sculpture: Some Recent Directions." *Portfolio including Art News Annual*, No. 1, 1959, p. 112.

Lewis, Jo Ann. "Art Will Be Considered Just as Important as the Bricks." *Art News* 75(December 1977):56.

_____ . "People Sculpture: Objections Overruled." *Art News* 77(December 1976):83–85.

Maitland, Leslie. "Factory Brings Sculptors' Massive Dreams to Fruition." *New York Times*, 24 November 1976, p. C35.

Northrop, Edward S. and Mitchell, John Blair. "Forum Page: Public Art vs. Public Safety." *American Artist* 40(December 1976):8.*

O'Doherty, Brian. "Boredom and the Amiable Android." *Object and Idea: An Art Critic's Journal, 1961 to 1967*. New York: Simon and Schuster, 1967; reprinted from the *St. Louis Post-Dispatch*, September 1965.

Oeri, Georgine. "Documentation: George Sugarman." *Quadrum*, no. 12, 1961, p. 152–153.

Rose, Barbara and Sandler, Irving. "Sensibility of the Sixties." *Art in America* 55(January/February 1967):44. Statement by the artist.*

Sandler, Irving. "Is There a New Academy?" *Art News* 58 (September 1959):37,60. Statement by the artist.*

_____ . "Sugarman Makes a Sculpture." *Art News* 65(May 1966):34–37.*

Simon, Sidney. "George Sugarman." *Art International* 11 (May 1967):22–26.*

Strickler, Madeleine and Keller, Dominik. "Atelierbesuche: George Sugarman." *Du: Die Kunstzeitschrift* 6(June 1979):54.

Sugarman, George. George Sugarman Papers (GSP). Manila file folder belonging to the artist entitled "Jottings, Ideas, and Articles" which were written and collected in the sixties. These notes are a combination of handwritten notes on scratch pads, rough-typed thoughts, manuscripts for statements and clippings, and quotes from books and articles which Sugarman collected. Many of these are on microfilm in the Archives of American Art, Washington, D.C., which also contains drawings, letters to Sugarman, and exhibition announcements.*

Sugarman, George. Interviews with Holliday T. Day at the artist's studio, New York (unpublished), 16 July 1980, 20 October 1980, 13 February 1981.*

Sugarman, George. Sugarman Statements (SS). Robert Miller Gallery, New York. These are two typed statements: one on public art of two pages, undated, and one on decorative art of four pages, November 1978.*

Washington, D.C. Archives of American Art. *George Sugarman Papers*.

GENERAL REFERENCES THAT MENTION SUGARMAN

Andersen, Wayne V. *American Sculpture in Process 1930/70*. Boston: New York Graphic Society, 1975.

Ashton, Dore. "George Sugarman." *The Britannica Encyclopedia of American Art*. Chicago: Encyclopaedia Britannica Educatinal Corp., 1973.

_____ . *Modern American Sculpture*. New York: Harry Abrams, 1968.

Bevlin, Marjorie J. *Design Through Discovery*. New York: Holt, Rinehart & Winston, 1977.

Busch, Julia. *A Decade of Sculpture: The 1960s*. Cranbury, New Jersey: Associated University Presses, 1974.

Calas, Nicolas and Elena. *Icons and Images of the Sixties*. New York: E. P. Dutton & Co., 1971.

Cummings, Paul, ed. *Dictionary of Contemporary American Artists*. 3rd ed. New York and London: St. Martin's Press and St. James Press, 1977.

Dienst, Rolf-Günter. *Positionen: malerische Malerei, plastiche Plastik*. Keulin, 1968.

Fundaburk, Emma Lila, and Davenport, Thomas G. *Art in Public Places in the United States*. Bowling Green, Ohio: Bowling Green University Popular Press, 1975.

Hunter, Sam. *American Art of the 20th Century*. New York: Harry Abrams, 1972.

_____ . "American Art Since 1945," in *New Art Around the World: Painting and Sculpture*. New York: Harry Abrams, 1966.

Janis, Harriet, and Blesh, Rudi. *Collage: Personalities, Concepts, Techniques*. Philadelphia and New York: Chilton Co., 1962.

Kahmen, Volker. *Erotic Art Today*. Translated by Peter Newmark. Greenwich, Connecticut: New York Graphic Society, 1972.

Kelly, James J. *The Sculptural Idea*. Minneapolis: Burgess Publishing Co., 1974.

Knobler, Nathan. *The Visual Dialogue: An Introduction to the Appreciation of Art*. New York: Holt, Rinehart & Winston, 1967.

Kultermann, Udo. *The New Sculpture: Environments and Assemblages*. New York: Praeger, 1968. A translation of *Neue Dimensionen der Plastik*. Tübingen: Wasmuth, 1967.

Lippard, Lucy R. "Diversity in Unity: Recent Geometricizing Styles in America," in *Art Since Mid-Century, The New Internationalism*, vol. 1 of *Abstract Art*. Greenwich, Connecticut: New York Graphic Society, 1971.

Meelach, D.Z. *Contemporary Art With Wood*. 1968.

Naylor, Colin, and Porridge, Genesis, eds. *Contemporary Artists*. New York and London: St. Martin's Press and St. James Press, 1977.

O'Doherty, Brian. *American Masters: The Voice and the Myth*. New York: Random House, 1973.

_____. *Object and Idea: An Art Critic's Journal, 1961 to 1967*. New York: Simon and Schuster, 1967.

Redstone, Louis G. and Ruth R. *Public Art: New Directions*. New York: McGraw-Hill, 1981.

Rickey, George. *Constructivism: Origins and Evolution*. New York: George Braziller, 1967.

Robinette, Margaret A. *Outdoor Sculpture: Object and Environment*. New York: Whitney Library of Design, 1976.

Rose, Barbara. *American Art Since 1900: a Critical History*. New York: Praeger, 1967.

Rosenberg, Harold. *Art Works and Packages*. New York: Horizon Press, 1969.

Sandler, Irving. "Gesture and Non-Gesture in Recent Sculpture," in *Minimal Art: A Critical Anthology*. Edited by Gregory Battcock. New York: E.P. Dutton, 1968.

_____. *The New York School: The Painters and Sculptors of the Fifties*. New York: Harper and Row, 1978.

Thalacker, Donald W. *The Place of Art in the World of Architecture*. New York: Chelsea House, R.R. Bowker, 1980.

*Asterisks indicate extensive articles or catalogues on Sugarman.

Major Commissions

CIBA-GEIGY Corporation, Ardsley, New York

City of Leverkusen, West Germany

Empire State Mall, Albany, New York

Federal Court Building, Baltimore

First National Bank of St. Paul, Minnesota

Albert M. Greenfield School, Philadelphia

International Building, Airport, Miami

Lincoln National Life Building, Ft. Wayne, Indiana

New Detroit Receiving Hospital and University Health Center, Detroit

Public Library, Akron, Ohio

Wills Eye Hospital, Philadelphia

World Trade Center, Brussels

Xerox Data Systems, El Segundo, California

Lenders to the Exhibition

The Art Institute of Chicago

Mrs. Robert M. Benjamin

Joint Art Commission, New Detroit Receiving Hospital and University Health Center, Wayne State University, Detroit

Massachusetts Institute of Technology, Cambridge

Robert Miller Gallery, New York

The Museum of Modern Art, New York

Mary and Leigh Block Gallery, Northwestern University, Evanston, Illinois

Springfield Museum of Fine Arts, Massachusetts

George Sugarman

Jane Suydam

Helen F. Spencer Museum of Art, The University of Kansas, Lawrence

The George Peabody Collection of Vanderbilt University, Nashville

Walker Art Center, Minneapolis

Whitney Museum of American Art, New York

Mr. and Mrs. David Michael Winton

Galerie Rudolf Zwirner, Cologne, West Germany

Acknowledgments

The organization of *Shape of Space: The Sculpture of George Sugarman* required the support and dedication of many individuals, and I am pleased to acknowledge them.

I am especially grateful to George Sugarman for his enthusiastic support; to him the greatest praise must be conveyed for he has brightened our lives with his art.

Holliday T. Day suggested this exhibition to me, which she curated, and has written the essay on Sugarman's contribution to the development of American sculpture. Irving Sandler, long-time follower of Sugarman's work, has given us a fresh interpretation of Sugarman's involvement with the formal ideas of the sixties. Brad Davis' memories as Sugarman's assistant provide valuable insight into Sugarman's working methods and thinking, and we are appreciative of his contribution to the catalogue.

Jane Allen edited the essays and deserves our special thanks as do those individuals who helped shape the concept for Ms. Day's essay. For her, I would like to warmly acknowledge: Brad Davis, Al Held, Joyce Kozloff, Robert Kushner, Susan Michod, Paul Cummings, and Barbara Zucker.

Special appreciation must be extended to the Robert Miller Gallery and its director, John Cheim, who provided excellent documentation on Sugarman's life and career.

The broad scope of the exhibition has been made possible by a generous grant from the National Endowment for the Arts to whom we are very grateful. We are also appreciative of the support from the museums which will present the exhibition and of their directors: The Institute of Contemporary Art, Philadelphia, Janet Kardon, Director; and the Columbus Museum of Art, Ohio, Budd Harris Bishop, Director.

Theodore W. James had overall responsibility for the exhibition. The transportation and installation assignments were handled by Edward R. Quick, assisted by Berneal Anderson, Charmain Schuh, and Earl Seeley. Ruby Hagerbaumer typed the entire manuscript in addition to assisting with the details of coordinating the exhibition. Audrey Gryder, Candace Clements, and Sue Dilts served as copy editors for the catalogue.

The arduous task of compiling the Chronology and Bibliography for the

catalogue was undertaken by Miriam Roberts. Barbara Grocki and Suzanne Wise assisted with the research.

Special thanks must be extended to the lenders for their generosity has allowed us to present Sugarman's work fully.

HFR, Jr.